RICHARD DIEBENKORN

FIGURATIVE WORKS ON PAPER

INTRODUCTION BY John McEnroe

ESSAYS BY Jane Livingston and Barnaby Conrad III

IN COOPERATION WITH GALLERIA LAWRENCE RUBIN, MILAN

RICHARD DIEBENKORN

JOHN BERGGRUEN GALLERY

SAN FRANCISCO

CHRONICLE BOOKS
SAN FRANCISCO

This book is dedicated to Phyllis Diebenkorn in appreciation
of her vision and for her willingness to share these works with the
many people who love the art of Richard Diebenkorn.

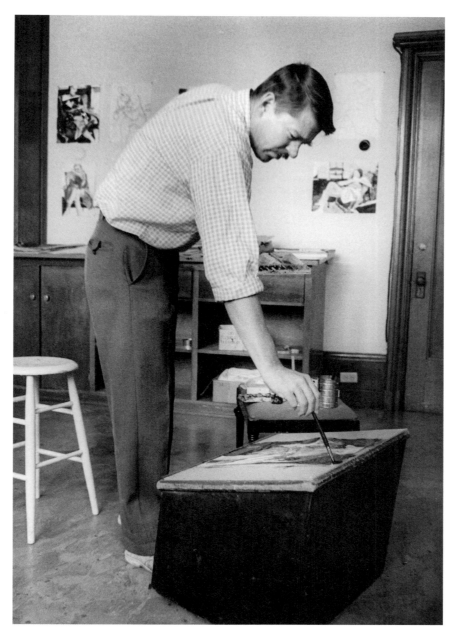

RICHARD DIEBENKORN IN HIS STUDIO, STANFORD, CALIFORNIA, 1963

OUR PERSONAL PASSION for Richard Diebenkorn's work has influenced and enhanced our lives as we have followed, exhibited and privately collected his works.

It is, therefore, with great pleasure that we present this exhibition of figurative works on paper by Richard Diebenkorn. This survey of drawings, watercolors and gouaches provides an opportunity to appreciate the beauty and range of the work of an artist who embraced change and yet rigorously remained true to his unique vision as a painter.

For the honor of presenting this exhibition and for her friendship and generosity, we sincerely thank Phyllis Diebenkorn. We wish to express our warmest gratitude to Gretchen Diebenkorn Grant and Richard Grant for their help and guidance. We are also indebted to our friend and colleague Lawrence Rubin for making this exhibition possible.

GRETCHEN & JOHN BERGGRUEN
SAN FRANCISCO

THE BIGGEST COMPLIMENT I ever received during my tennis career was to be called an artist on the court. Now what exactly did that mean, and what did it mean to me? In short, it was the ultimate achievement. I had brought my own seemingly effortless style to the court, and I had what people saw as a "feathery touch," an ability to do anything with the ball without bludgeoning it. Clearly, I see comparisons between artists and tennis players. I've always thought these two fields are filled with people cut from the same cloth. They often feel alone, perhaps cocky and yet unsure of themselves at the same time, but ultimately are trying to make an impression, to make their mark.

If Richard Diebenkorn had been a professional tennis player, he would have been a rare breed; someone who could do it all on any surface and do it well. His ability to move between serious exploration of abstraction and representational art reminds me of someone who began his career playing mainly from the baseline, later learned how to attack the net, and then settled back to using his ground strokes, albeit in a more geometric way. That's the versatility and grace I see in Richard Diebenkorn's art.

Richard Diebenkorn was successfully versatile for many years, and he did it his way. In this survey of figurative works

from the late 1950's and early 1960's, he produced beautiful, fully developed drawings and gouaches at a time when he himself questioned the viability of making representational art. Inspired and encouraged by his mentor David Park, Diebenkorn displayed consistency as a draftsman and a willingness to experiment with form and color that was exceptional. His use of color in his gouaches brings to mind an almost Fauve-like quality, but with the elusive yet recognizable "Bay Area perspective." His drawings, both with and without a model, remind me of two truly great artists of the twentieth century, Henri Matisse and Egon Schiele. Here are drawings where every line counts, others where Diebenkorn uses ink wash to create his desired effect, and still others where he applies the pencil much more forcefully, extracting an almost geometric quality from his subject. Most important when you look at these works, you quickly recognize them as uniquely Richard Diebenkorn.

Add my name to the list of people who believe Richard Diebenkorn to be a truly great artist. I attended Stanford University a generation after he had made his mark there. I only wish I had had the good fortune of meeting this art giant to further understand his masterful use of line, color and paint.

JOHN McENROE
NEW YORK CITY

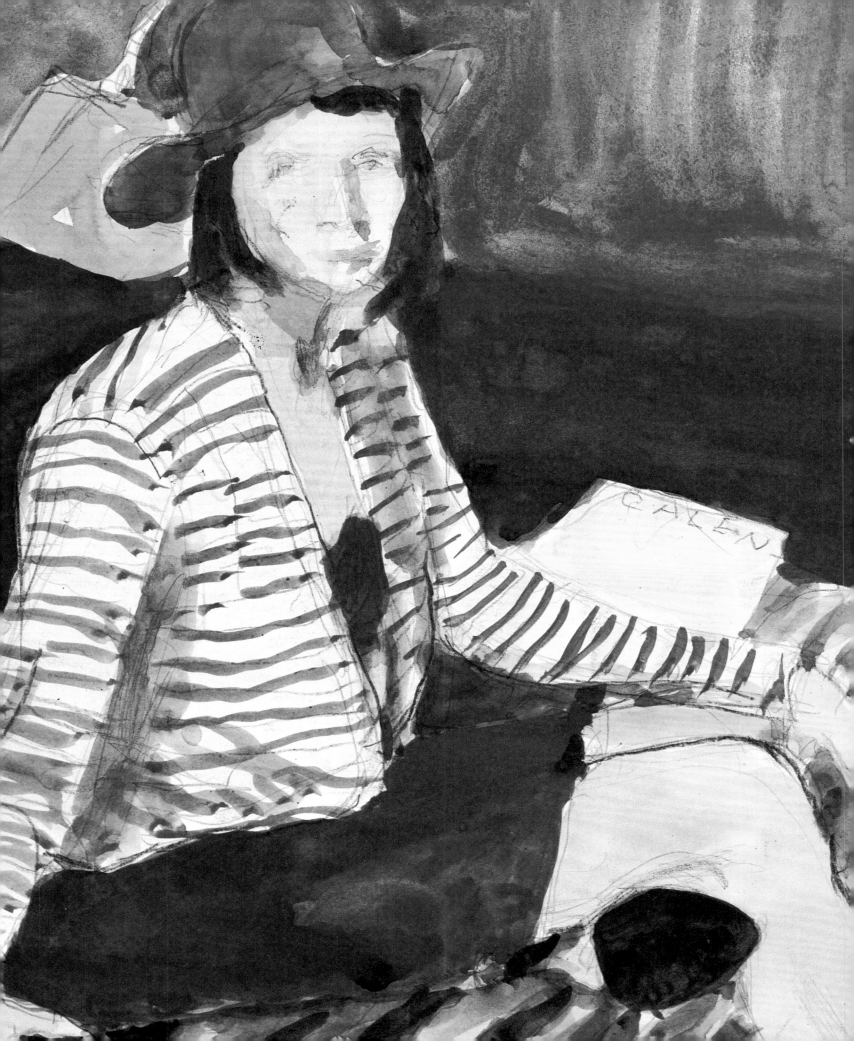

RICHARD DIEBENKORN

MODERNIST HUMANIST

JANE LIVINGSTON

This exhibition of representational works on paper by Richard Diebenkorn introduces objects whose variety and quality is surprising even to those of us who thought we knew the oeuvre pretty well. For reasons more accidental than deliberate, certain of Diebenkorn's drawings have remained out of circulation, possibly unseen even by the artist's closest dealers, curators and friends. We knew some important works hadn't been fully brought to light, but not how extraordinary they were. Long before his death, and until recently, they were carefully stored in drawers, not gotten around to, perhaps not pulled out by the artist while he was working with a museum scholar simply because others were more to hand. The fortunate occasion of these works' excavation is an event to be taken seriously indeed.

In this show we are faced with an opportunity to reassess this artist's fundamental balance of priorities. In all of the quite voluminous writing on Richard Diebenkorn's art, several themes were developed early, and have been revisited. Perhaps the most fascinating and puzzling aspect of his prodigious evolution is his trajectory from a youthful yet markedly mature abstract style (a body of work nearly unequalled in the youthful period of any of his peers); into a prolonged era during which the artist drew and painted figures, still lifes and landscapes; then into the great final cycles of abstract paintings and drawings known as Ocean Park works, and the Clubs and Spades. Each of his critics and scholars has pondered these shifts, and the strange repleteness of each phase.

The second remarkable fact of Diebenkorn's artistic approach is his lifelong project of mastering various media, and—perhaps even more difficult—his ability to work with equal proficiency in dramatically different scales. During virtually every stage of his explorations, he alternated between working on paper and on canvas, one medium seemingly reinforcing the other, but with a wholeness of commitment to each that made each its own full-fledged enterprise. The techniques of oil painting, and of watercolor, gouache, pencil, charcoal, collage, were mastered early on but never completely taken for granted. Even more, the diligent observation of nature and of the human form could somehow never be exhausted in his ongoing quest.

But the third incontrovertible attribute of Diebenkorn's art is its deep and complex yearning for idyllic human empathy and desire, an expression of *luxe et volupte.* He had an impulse to engage the traditions of such draughtsmen as Courbet and Géricault, at least in the sense of their

command of human psychology. This painter is most commonly compared with such peers as Willem de Kooning and Mark Rothko; he, like them, worked through an apprenticeship leading to a kind of consummate abstraction. It is time to consider that these more fully committed abstractionists never remotely attempted, much less achieved, Diebenkorn's command of a language of psychological, even narrative, sensuality. This vocabulary sprang from the same kind of synthesis of traditional craftsman discipline, and searching experimentation, that we associate equally with Matisse and Picasso. Both of them obsessively studied nature. Both studied and dissected and offered up their tributes to the female form, in its infinite manifestations. During the years from about 1955 to 1967, Diebenkorn organized frequent studio sessions with models—sometimes with fellow artists, other times alone. His searching, inventive attacks on the ancient problem of capturing (or posing) the figure, and the figure's relationship to architecture and furniture and draperies, suggest a discipline worthy of Ingres or Degas.

Yet even more intense was Diebenkorn's habitual scrutiny, on a less deliberative level, of facial expression and of subtle relationships among textures, colors and light-and-shadow compositions that occurred constantly and without artifice or conscious arrangement. Richard Diebenkorn, that creator of the famously grand, opulent and luminous Ocean Park paintings, turns out to be one of the twentieth century's most accomplished masters of modernist figuration, and of the intimate world of still life and of ordinary domestic existence. Faces, however, presented an artistic problem that would come into opposition with his endless search with an overall rightness, or fullness, created within a single drawing or painting.

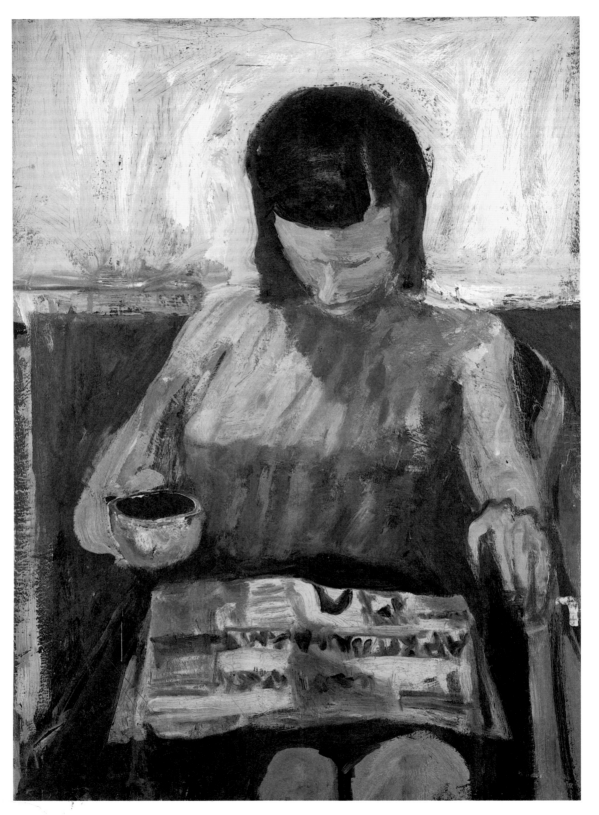

PLATE I

RD 1302

Anyone who has mastered the handling of the human figure at the level achieved by this artist will have spent countless hours drawing from life, and will have made endless sketches. Diebenkorn was careful to distinguish between works made as studies, or works not completed, or not finally satisfactory to himself, that were consciously kept apart from the official oeuvre. But that others of such wholly integral quality as these haven't been circulated, constitutes an event of major significance. Objects such as Plates 10, 17 and 39 are now being introduced into the Diebenkorn canon alongside many beloved images whose familiarity will make these new ones all the more ready for study and delectation.

These works fall into several types: the charcoal drawings, the more elaborate charcoal and ink wash drawings, and the more "fleshed out" gouaches. Within these groups are other categories—reclining or seated figures, standing figures, and heads. Diebenkorn's subjective separation of these genres, or artistic sub-traditions, itself gives us clues to his habitual engaging of the art of his forbears. For as restlessly independent and experimental an artist as he was, he grounded his achievement in French modernism, primarily that of Cézanne, Matisse and Bonnard. With this exhibition, we are also drawn to evince such an artist as Edvard Munch: who else recalls so immediately the compositional symmetry and the rhythmic, halo-like brushwork around a figure as the seated woman in Plate 16?

Richard Diebenkorn was ultimately searching for a sort of verisimilitude of mood, or of deeper emotion. Attitude was everything—attitude of physiognomy or posture, of the feeling of the moment shared by viewer and subject. The miracle of these works resides in their *repleteness* of being—

their existence in complete emotional pockets of being. Diebenkorn tended to privilege works by other artists in terms of their power to embody an honestly conveyed state of being—or even just a passing state of mind. It could be modest, but it had to be felt, and it had to be whole.

Diebenkorn often experimented with a mode of working in opposition to the sinuous, free-form linearity he so deftly commanded in his charcoal studies from the model. This other idea led him to an absolutely focused symmetry, always in small scale. The impulse was sometimes realized in abstract form, but is most fully demonstrated in the small faces or heads made in various media, ranging from oil on panel to watercolor on paper. The problem of physiognomy in his work haunted him as it did virtually every modern artist from Manet to Matisse, but in Diebenkorn's case the challenge was quite particular. He struggled in the matter of the recognizable identity of a person when it was rendered in full figure, sometimes resorting to a sort of generalized facial treatment rather than giving in to the convention of the portrait. The positioning and gesturing of the body often conveys more about the person represented, or thought of, than does the facial expression. On the other hand, Diebenkorn's concentrated faces, or "heads," as he called them, zero in on their subjects (usually generic, occasionally specific) in the most naked way. There is a kind of brutal confrontation implied in some of the face paintings that contrasts decisively with the much more attenuated psychology of the full figures. And yet the intimations of German Expressionist imagery—Jawlensky in particular—are usually close to the surface. Consider such an image as Plate 32.

In this exhibition, the several ravishing charcoal, ink and ink wash drawings may seem to dominate the field. This medium was one of

Diebenkorn's most fully expressed genres. But it doesn't take long to grasp the equally original seduction of his color drawings. It is as if he could shift from one to another of these absolutely different genres, or styles, with impunity. Although we know that Diebenkorn was often attracted to experimenting with color, his palette was sometimes consciously tamed, in the sense of being non-Fauvist, or of bearing a clear relation to the psychologically observable world. When he broke out of this habit of creating seemingly naturalistic chromatic worlds, to allow color and composition to inhabit an arbitrary, highly aestheticized, realm, he could invent incomparable worlds. Two pictures illustrate this point—Plates 31 and 38. It is impossible to imagine either of these images succeeding in any other palette than what is proclaimed. Color becomes the subject; line and texture bolster color; psychological undertones issue from these (abstract) attributes, rather than from the expressionism more common in this exhibition.

A safer, if exquisitely rich, palette, characterizes a gouache and watercolor which, while modest in scale and "conventional" in genre, shows Diebenkorn at his most confident, and most focused (Plate 3). The image of a nude standing in profile, facing to her right, left arm akimbo, synthesizes figuration and landscape, color and spatial composition, tradition and innovation. The monumentality created by the erectness of the figure, legs sharply truncated, sculpturally commanding purple-blue shadows anchoring her corporeality, demonstrate the artist's ability to compete with his many classical forbears. This is not a typical Diebenkorn composition. And yet it is incontrovertibly his. The repertoire is extraordinary.

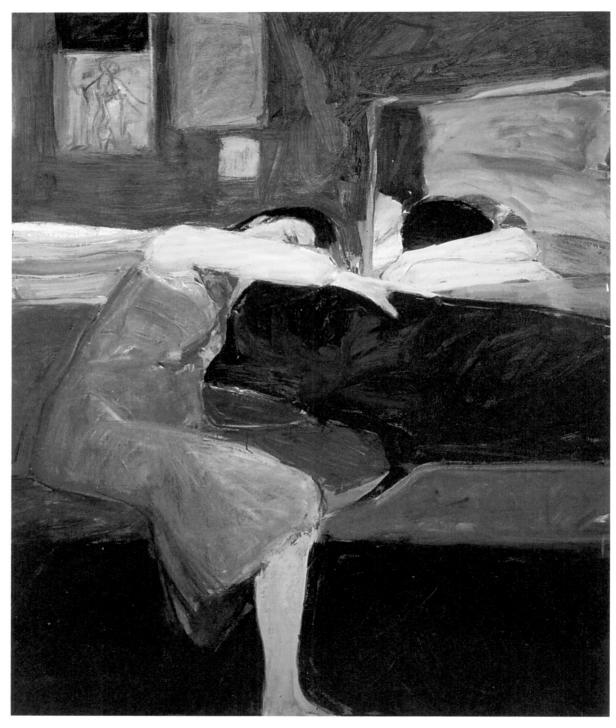

FIG. I SLEEPING WOMAN, 1961, OIL ON CANVAS, 70 X 58 INCHES, RD 1328

KALAMAZOO INSTITUTE OF ARTS, MICHIGAN

SECRET

KNOWLEDGE

FROM THE WEST COAST

BARNABY CONRAD III

Richard Diebenkorn's abstract paintings of the 1950s always hinted at figurative inspiration, mainly the arid Western landscapes of California and New Mexico. But in 1955, just as Abstract Expressionism was becoming the "academy" of modernism, this contrarian shocked many in the art world by returning to figures and landscapes. Eventually, in 1967 he abandoned the figure for the architectonic sublime of the Ocean Park series. In all three phases of his work, a distinctive character remains constant. As critic Mark Stevens once observed, "There is a Diebenkorn line, a Diebenkorn space and a Diebenkorn blue that belongs to no one else."

Diebenkorn was well into the Ocean Park series when I first met him in 1973, but it was his figurative work of 1955-67 that compelled me to

write him a fan letter. I'd seen his paintings in private homes around the Bay Area, and as an art student I'd kept a postcard of his *Sleeping Woman*, 1961, taped to my studio wall. No one in my class at Yale had ever heard of Diebenkorn, and only two professors knew his figurative work from shows at the Poindexter Gallery in New York in the 1950s and 1960s. (Many East Coast painters were still dismissive of the bold new work by former Abstract Expressionist, Philip Guston, who had recently returned to a cartoon-ish figurative style.)

For me as a young painter, Diebenkorn's figurative work was secret knowledge from the West Coast. I emulated my hero's sun-slashed cityscapes and moody women in dark, abstracted interiors. Finally, I wrote to him, saying I wished to study with him at UCLA. He wrote back saying that alas, he would no longer be teaching that fall, but that I could stop by his studio anytime. In July, of that Watergate-summer, I drove down from San Francisco to see him in Santa Monica.

His studio was above an appliance store in a quiet neighborhood called Ocean Park. Sam Francis also kept a studio in the same building. The outer door to the building was a stark piece of plywood that squealed as it opened. As I reached the top of the stairs a shadowy figure appeared on the landing. Tall and lanky as a woodsman, the artist had a full head of dark hair and glasses. I was relieved when my hero shook my hand and a smile broke under his broad moustache.

The studio was filled with huge canvases. There were a dozen gouaches from the Ocean Park series pinned up on one wall, but also a

charcoal drawing of rooftops and a telephone pole whose power lines criss-crossed the top of the page. So, I realized, Diebenkorn was still dipping back into figuration from time to time. As he settled into a metal folding chair—the subject of several major paintings—he mentioned that our only time constraint was that he wanted to watch the Watergate hearings on television that evening. I apologized for being late—car trouble.

"No problem," he said. "I've just been trying to work on this one here." He indicated a large canvas in grey and black. "It's in bad shape at this point." He frowned, then got up and turned the uncooperative canvas to the wall. "I'd rather show you another one that I feel has worked out pretty well." He stepped to the other side of the studio and hefted one of the 91 by 81 inch canvases, his long arms spread like an eagle. He swung it around and hung it on two hooks in the paint-splattered wall. I stared and stared at the painted, scraped, caressed and smudged canvas. It was wonderful, a vertical landscape of aquamarine washes and hot peachy tones compressed into the upper left corner. There was an architectural, even surgical aspect to some of his incised lines. "It's almost right," he said.

After allowing me to inspect and admire his work, he asked to see my own. I pulled out a dozen drawings of nudes and landscapes. Many of them looked like faked Diebenkorns, but he never revealed whether this pleased or annoyed him.

He gave each drawing serious consideration, generously treating me, a twenty-one-year-old student, like a fellow artist. In one gouache of a

nude, I'd used masking tape as a flesh tone, and I commented on it some-what sheepishly.

To my surprise, Diebenkorn pointed across the room to one of the unfinished Ocean Park gouaches, which bore several strips of masking, tape in the upper corner. He said, "I like the color of masking tape, too. It's useful." We had a connection!

Aware that his time was precious, I said I should probably let him get back to work, but he pointed to my portfolio. "Why don't we see some more?" He spent thirty minutes looking at two dozen drawings, some-times commenting favorably on the division of space and the variation of line, sometimes offering advice. "You might want to push this drawing further. It might not end up as pretty, but if you take a few more risks, you may come up with something less predictable." He gently conveyed to me that making art was of utmost seriousness, a combination of surgery, gambling and poetry.

That fall I took every cent I had, visited the Martha Jackson Gallery in Manhattan, and paid $150 for a black and white etching of a still-life in front of window, from his portfolio, 41 Etchings Drypoints, published in 1965 by Crown Point Press. As I moved from New York to Paris and back to San Francisco, it became a talisman, a reminder of Diebenkorn's high ideals and individuality.

Now, looking at this exhibition and book of Diebenkorn's figurative works on paper, it's hard to believe they were produced almost fifty years ago; they're still so fresh to the eye. They are intimate, poignant, moody,

and occasionally erotic. In a 1957 interview the artist said: "Reality has to be digested, it has to be transmuted by paint. It has to be given a twist of some kind." Diebenkorn applied intellectual rigor to his art, yet these figure drawings seem unguarded glimpses into a painter's private world. Each time the artist moved the pen, charcoal or ink-soaked brush across the page he took a risk, setting out in quest of the unknown. As he wrote in his studio notes around this time: "Attempt what is not certain. Certainty may or may not come later. It may then be a valuable delusion."

In one drawing he casually began a seated figure in blue ball-point pen, and then redrew it completely in bold strokes of charcoal. Mistakes were made, lines were erased, and their history remains as pentimenti, faded reminders that a struggle took place on the page. The Diebenkorn line could be cruel as it defined a sharp hipbone or sensuous as it lingered over a fleshy thigh. Loaded with ink wash, the brush might noodle-out an idiosyncratic geometry or release voluptuousness rivaling Bonnard and Matisse. Most of these drawings and paintings on paper have never before been published or exhibited. They are not studies for paintings, although one or two may have inspired larger works in oils. In many ways, they are lucky to exist: Diebenkorn was one of the strictest self-editors, throwing away many works that, in his words, couldn't be made "right."

Unquestionably the greatest artist to come out of California in the twentieth century, Diebenkorn was born in Portland, Oregon in 1922,

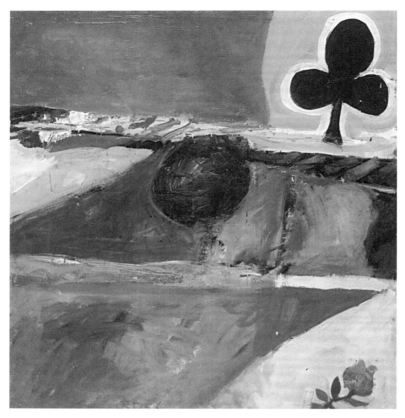

FIG. 2 LANDSCAPE WITH FIGURE, 1956, OIL ON CANVAS, 50¼ X 47⅝ INCHES
RD 1186, PRIVATE COLLECTION, CALIFORNIA

but grew up in San Francisco from the age of two. He studied art at Stanford and Berkeley, and painted most of his life in either the Bay Area or Los Angeles. When he entered the Marine Corps in 1943, he packed a Cézanne book in his seabag. Stationed near Washington, D.C., the young artist visited the Phillips Collection and was stunned by the great Matisses. His art grew from a complex mixture of American and European influences. As a child Diebenkorn was interested in the Bayeux Tapestry for its three-banded composition. Enthralled by the Arthurian

legends, he loved heraldic imagery, as well as the insignia of clubs and spades he saw on his grandmother's playing cards. A number of these biomorphic shapes surfaced in both the figurative and abstract paintings, for example, *Landscape with Figure* , 1956 (page 24). At Stanford he fell under the influence of Hopper, Cézanne, Matisse and Mondrian. While a student at the California School of Fine Arts, he absorbed the philosophies of the sublime expounded by Clyfford Still and Mark Rothko. He loved music, from the latest jazz LPs to Beethoven and Mozart, which he listened to while he painted. He admired Willem de Kooning's virtuosity and knew the art theory of Clement Greenberg and Harold Rosenberg who were defining the New York School. But he always went his own way.

Suddenly, after seven years as an abstract painter, Diebenkorn joined colleagues David Park and Elmer Bischoff in what became known as the Bay Area Figurative School. The human figure as a well as still-lifes and landscapes appeared in his large painterly canvases. "Temperamentally," he once said, "I have always been a landscape painter." Never content to repeat himself, in the mid-1960s Diebenkorn moved to Los Angeles, and the figurative works morphed into the large Ocean Park series for which he is best known.

Diebenkorn's death in 1993 was a blow to all who had known and admired him, but his 1998 retrospective at the Whitney Museum (curated by Jane Livingston) was a triumph, a fitting tribute to a twentieth-century giant.

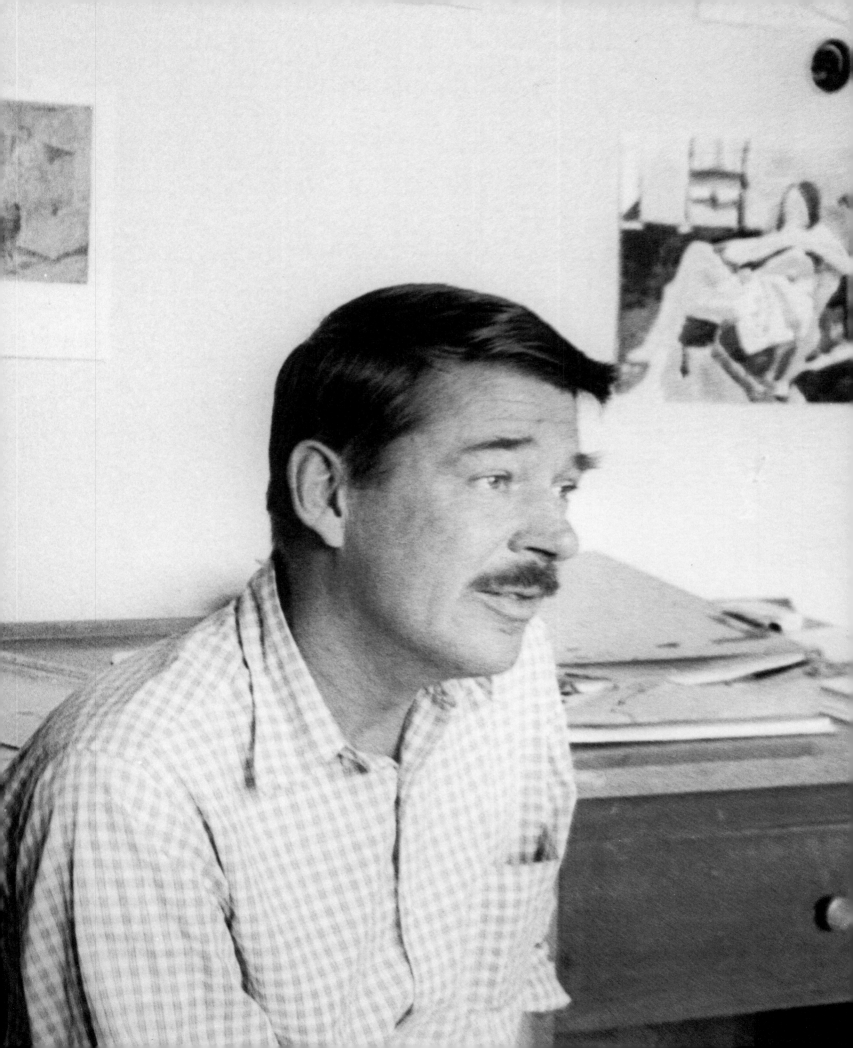

PLATE 2

RD 743

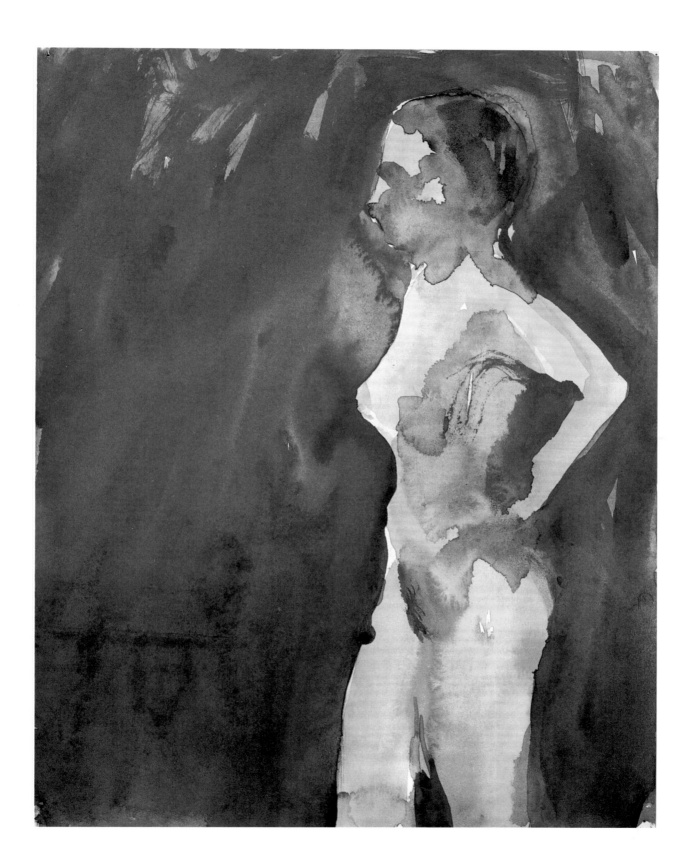

PLATE 3

RD 751

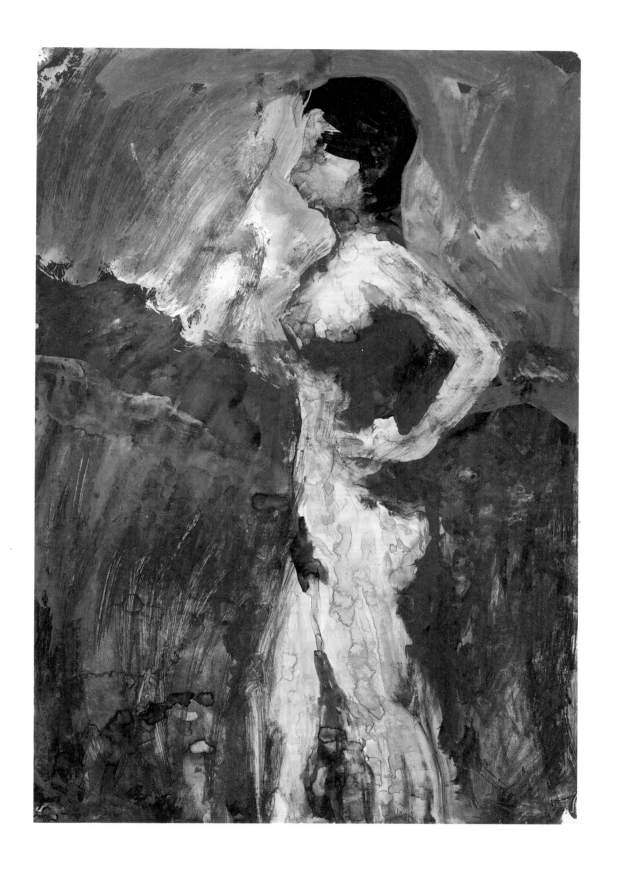

PLATE 4

RD 810

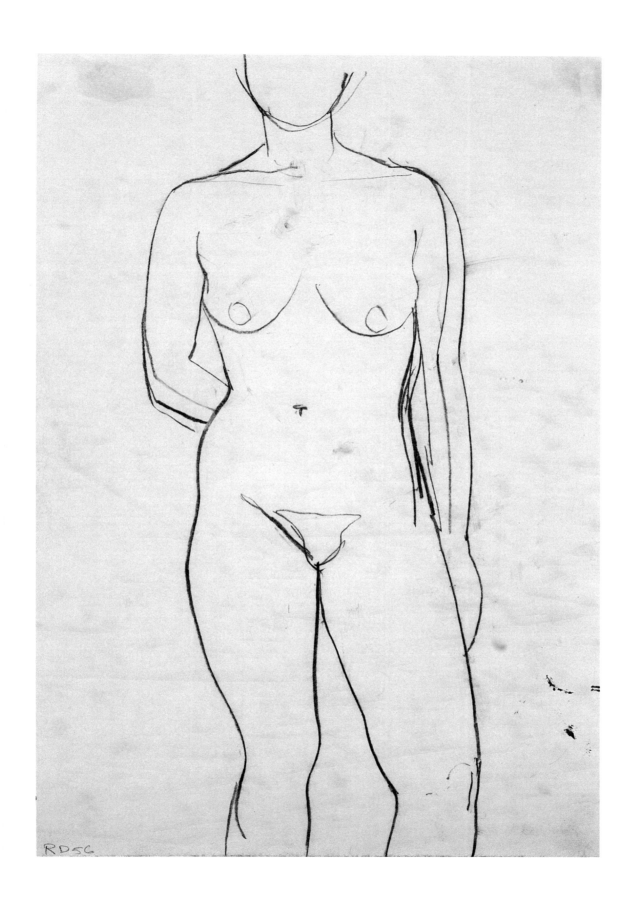

RD56

PLATE 5

RD 511

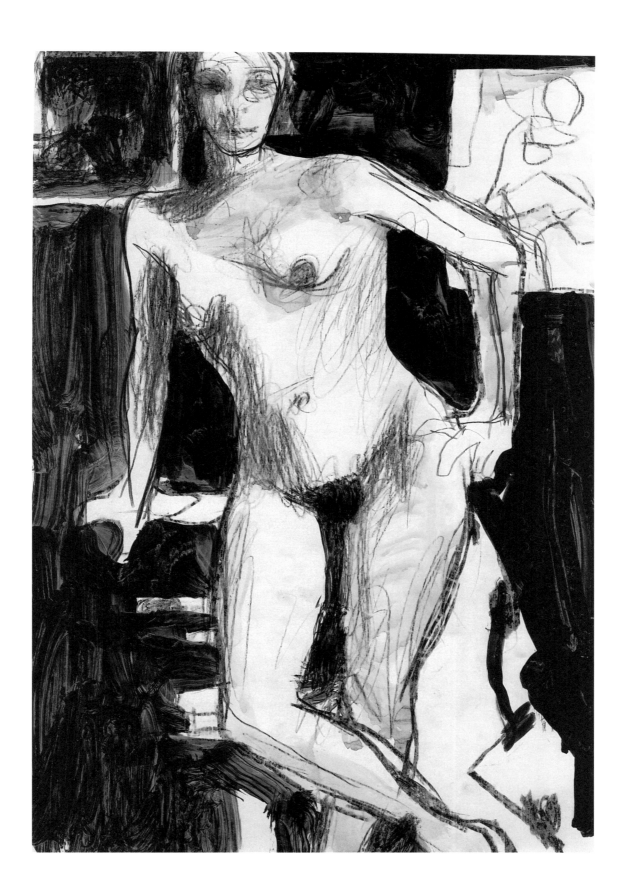

PLATE 6

RD 2096

36

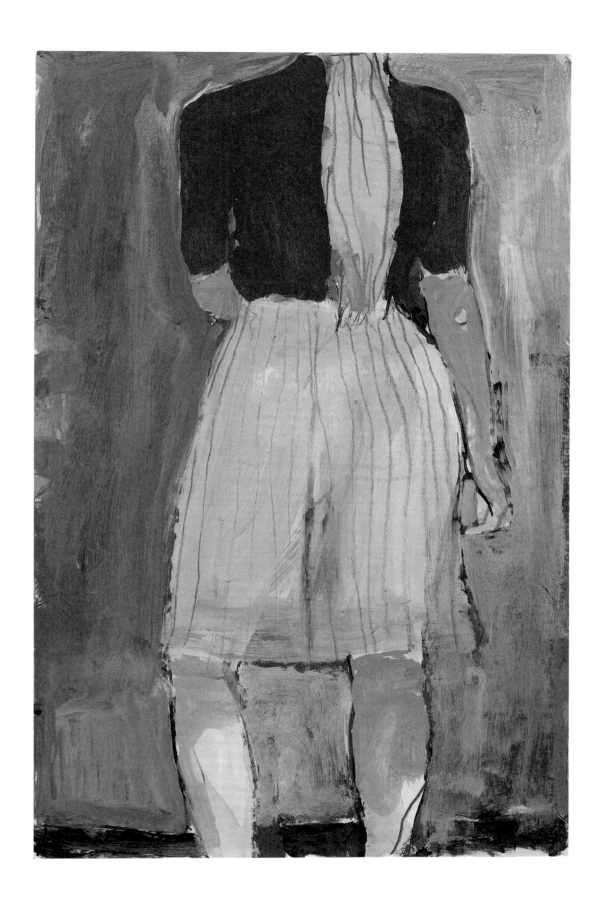

PLATE 7

RD 968

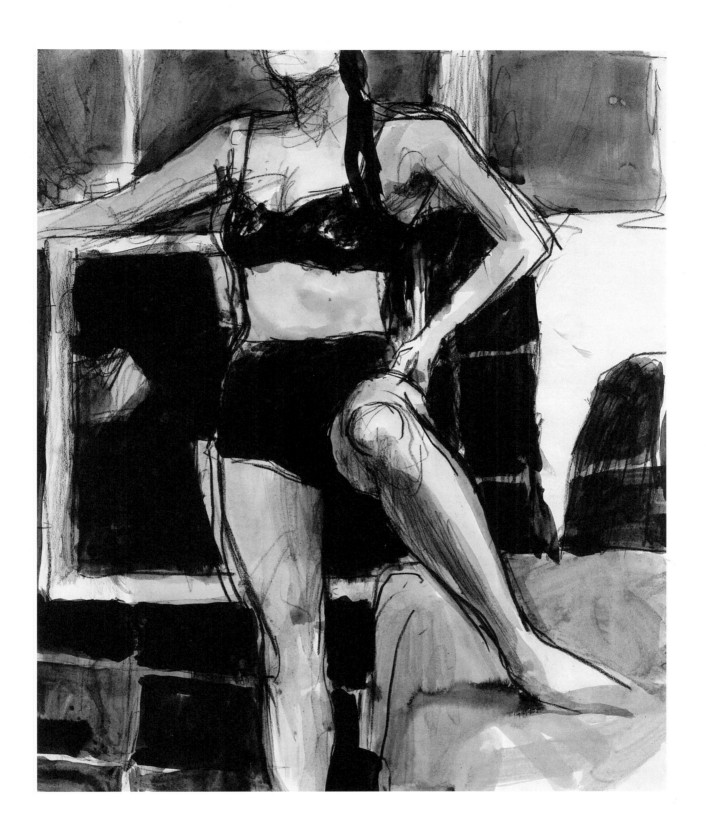

PLATE 8

RD 836

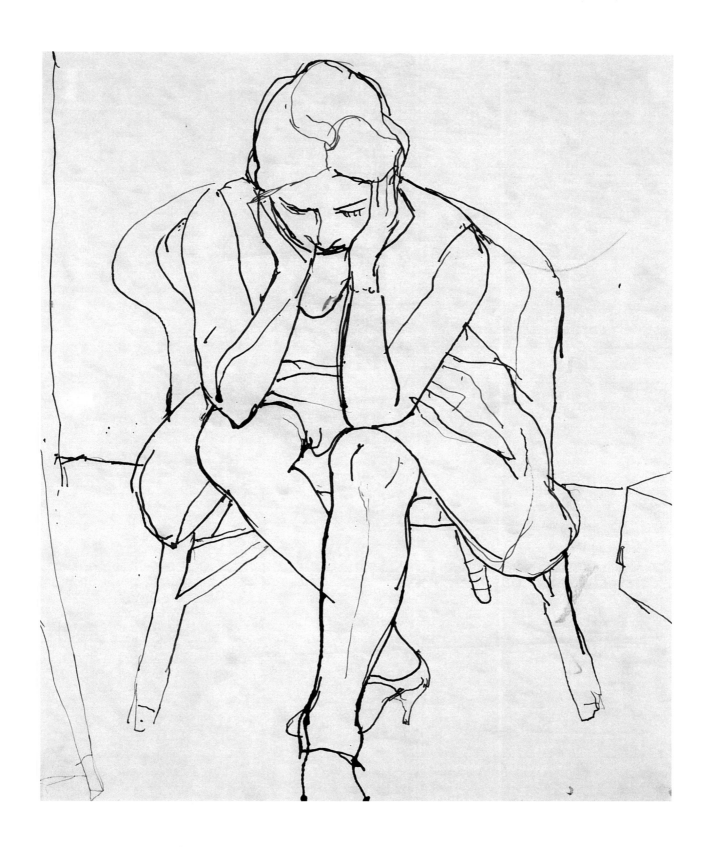

PLATE 9

RD 878

42

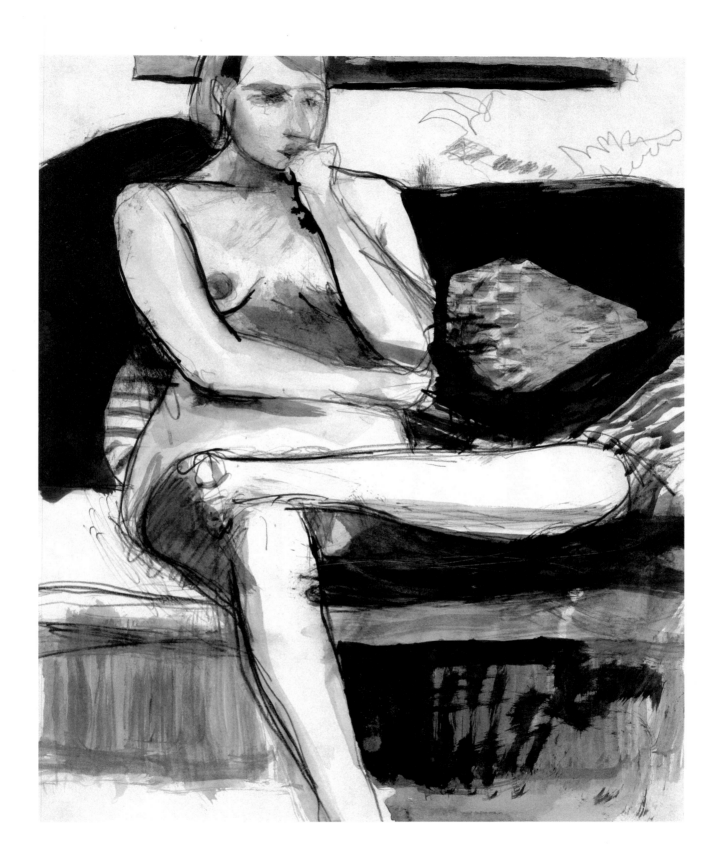

PLATE 10

RD 868

44

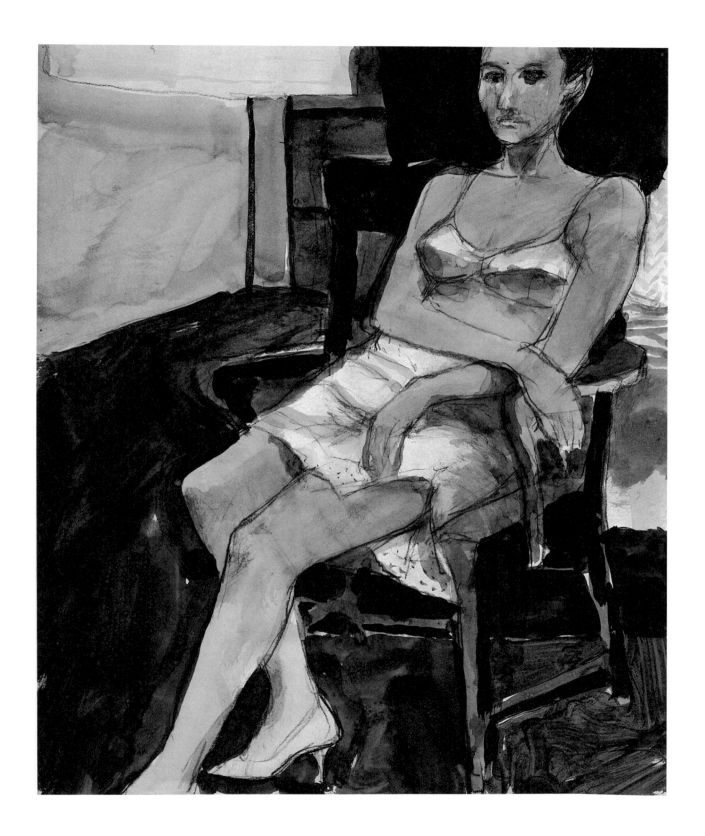

PLATE II

RD 889

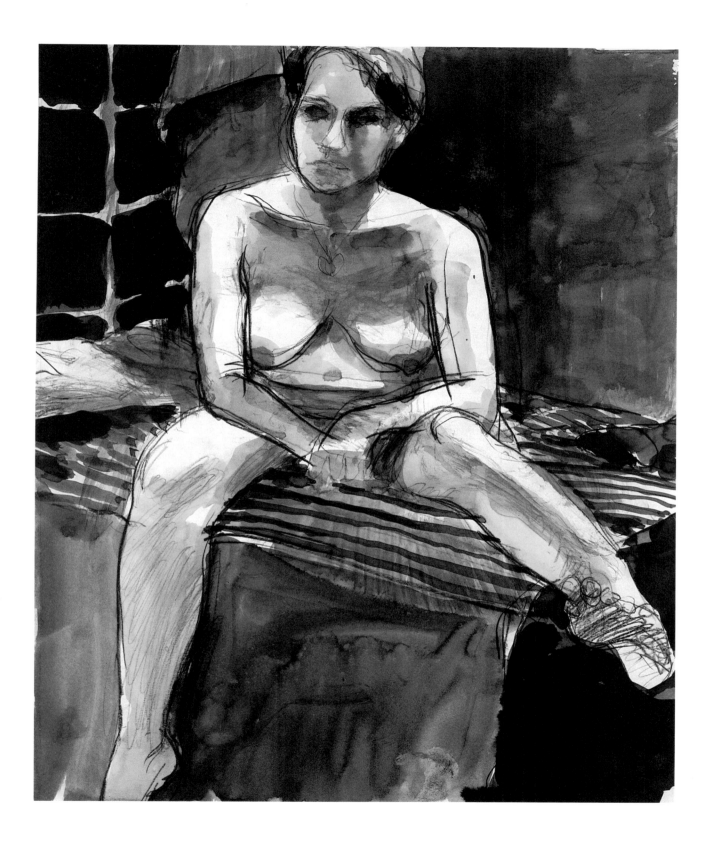

PLATE 12

RD 879

48

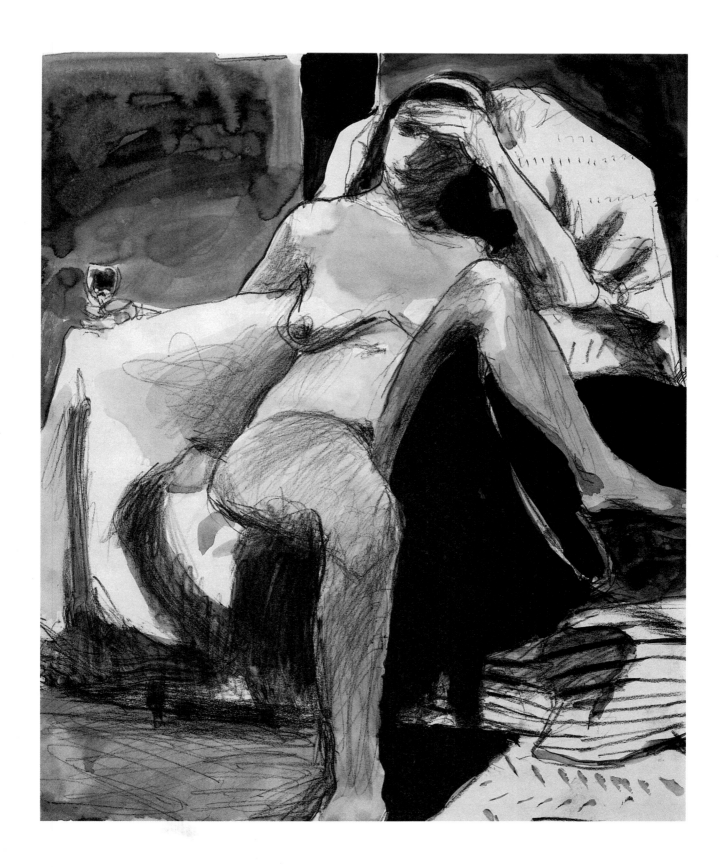

PLATE 13

RD 2101

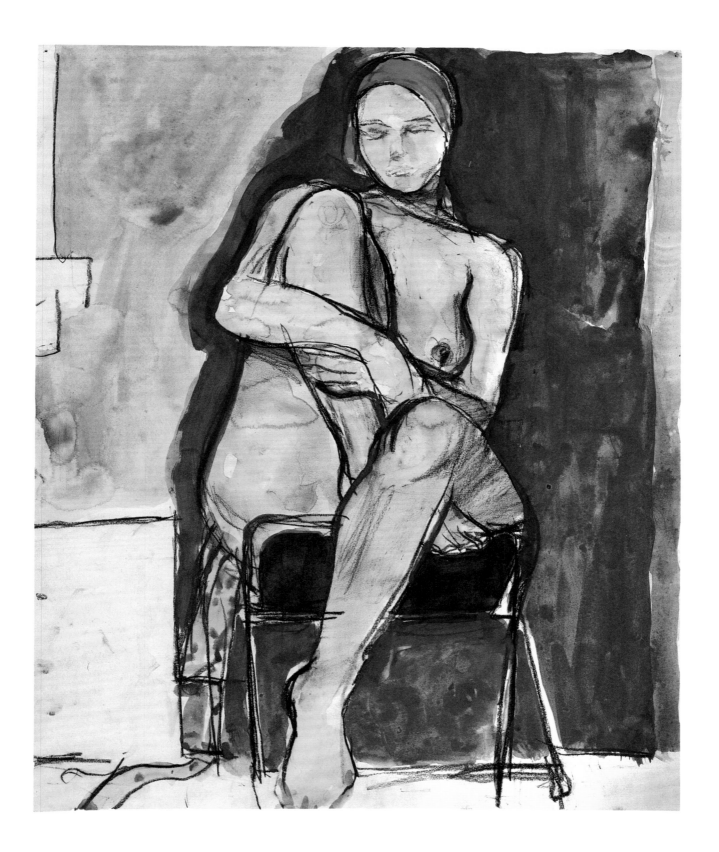

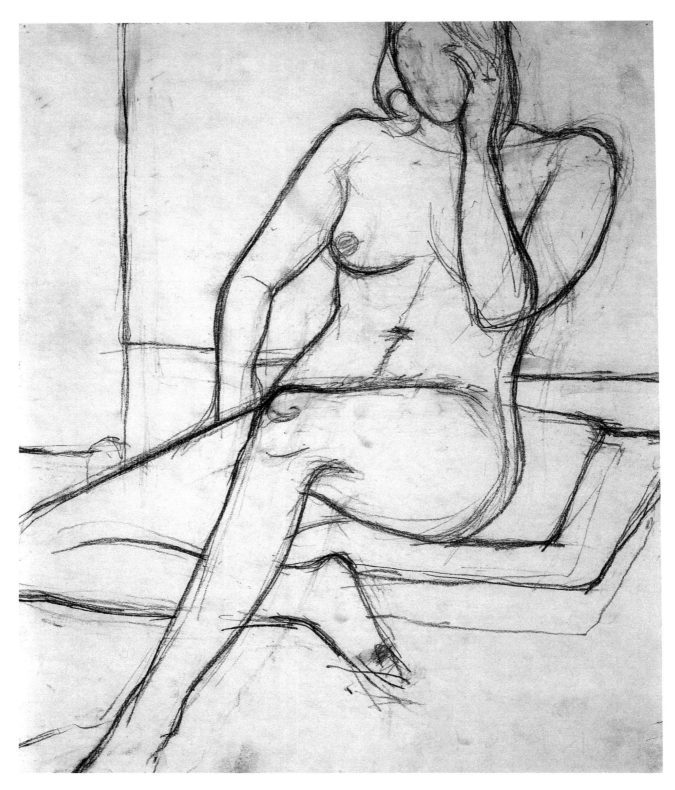

PLATE 14

RD 831

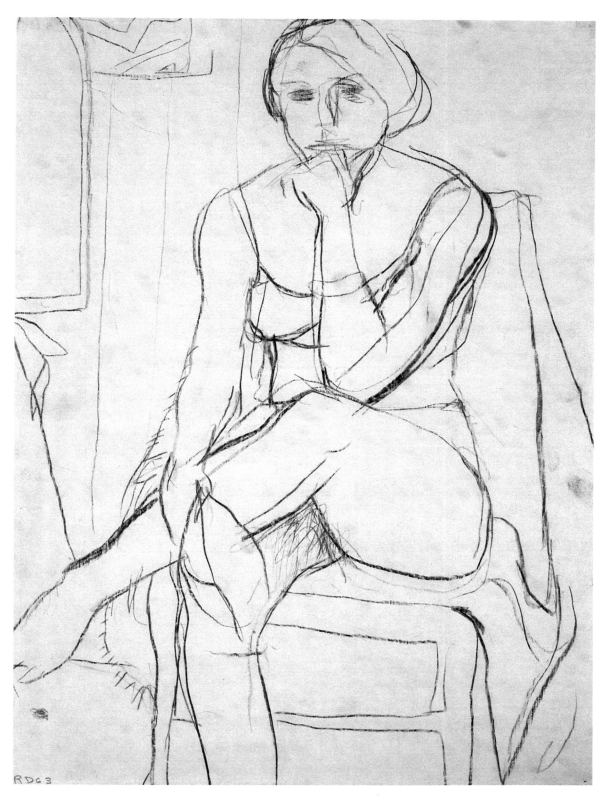

PLATE 15

RD 925

PLATE 16

RD 2088

54

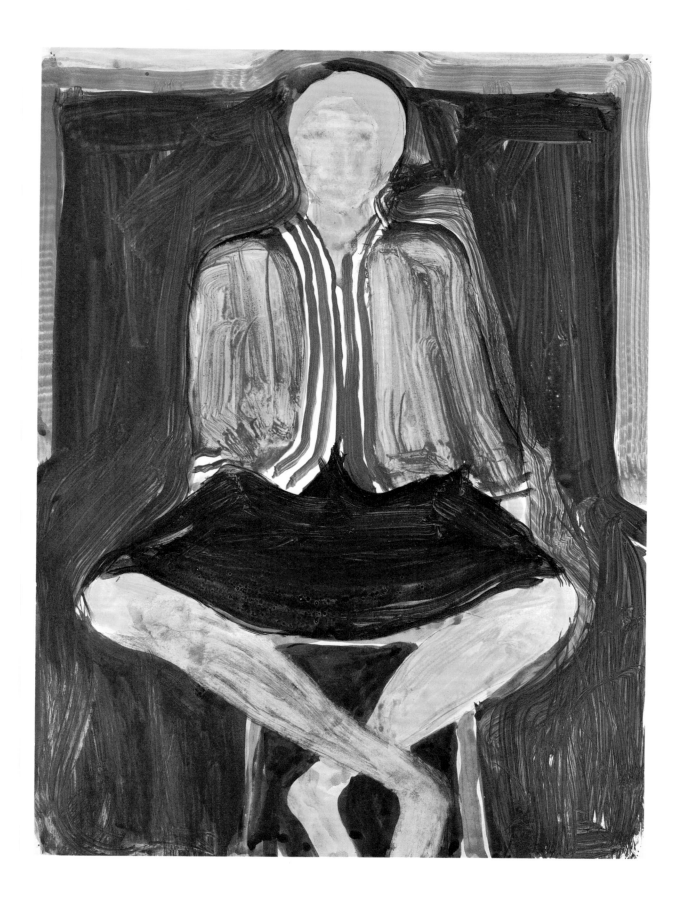

PLATE 17

RD 930

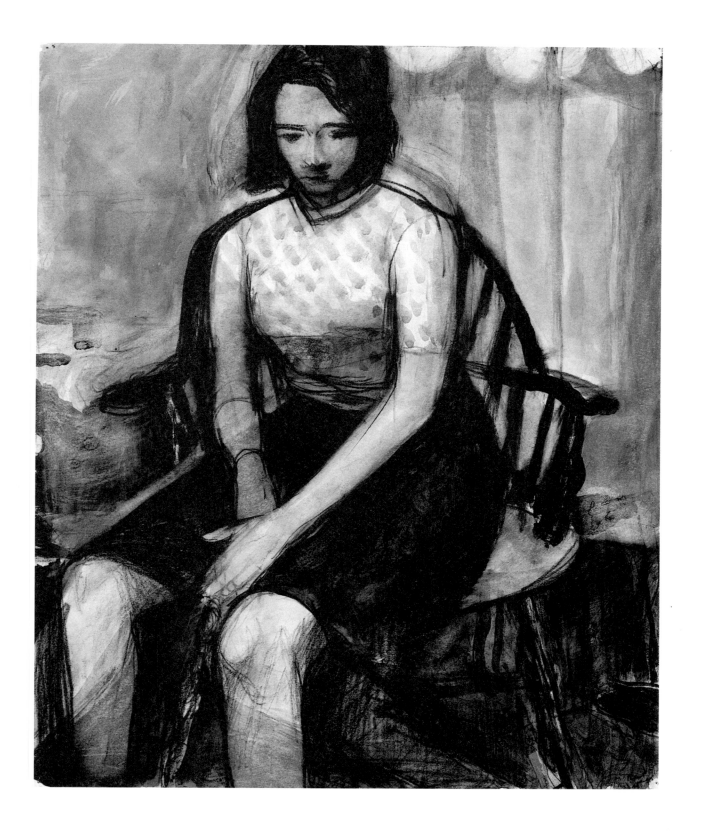

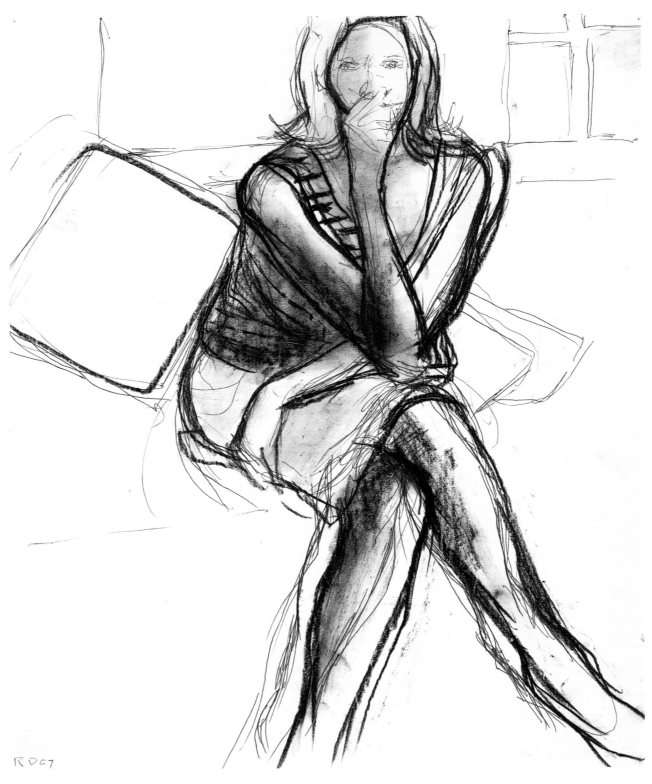

RDC7

PLATE 18

RD 1735

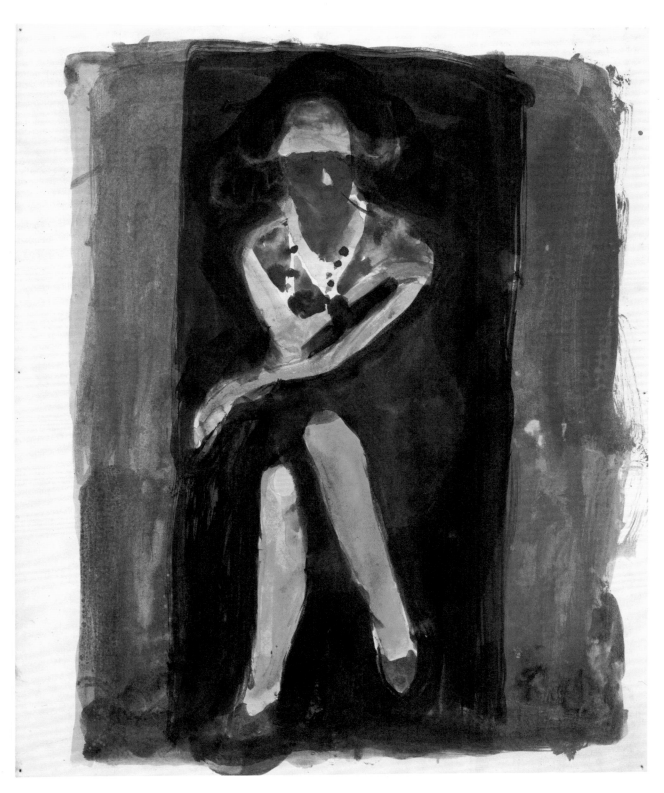

PLATE 19

RD 782

PLATE 20

RD 1734

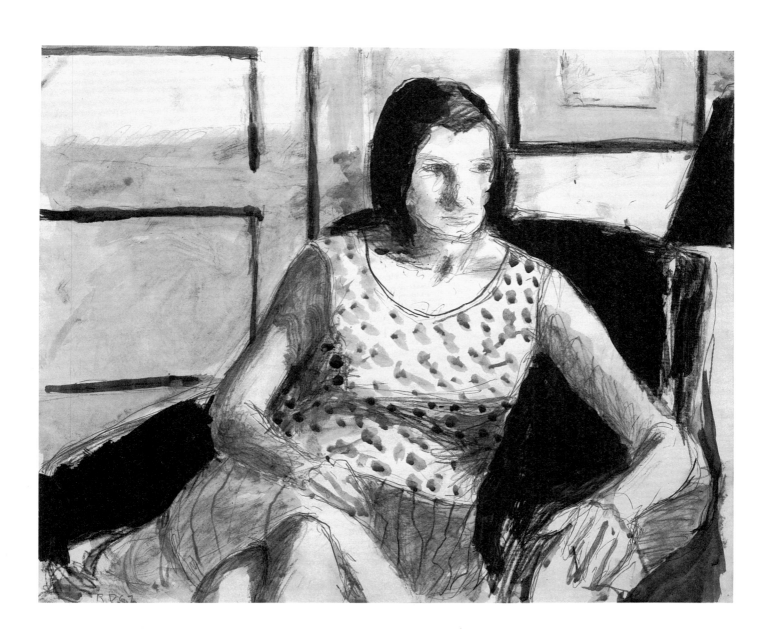

PLATE 21

RD 2098

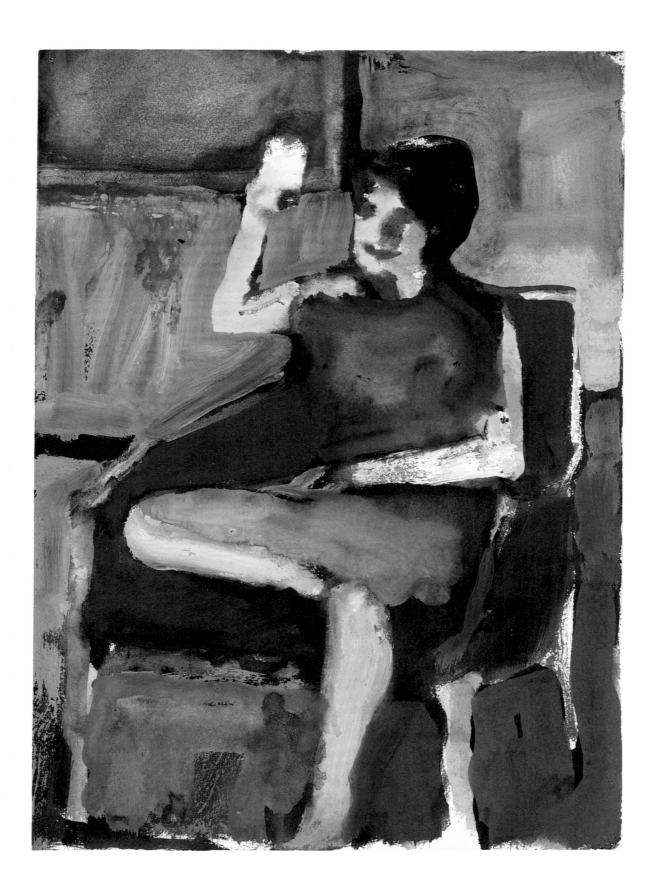

PLATE 22

RD 975

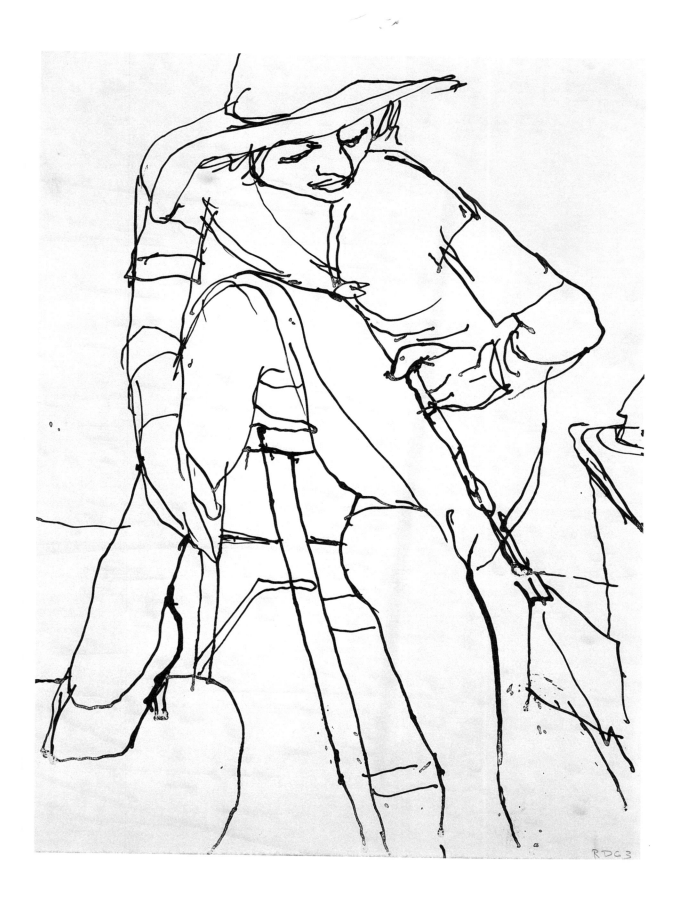

PLATE 23

RD 2004

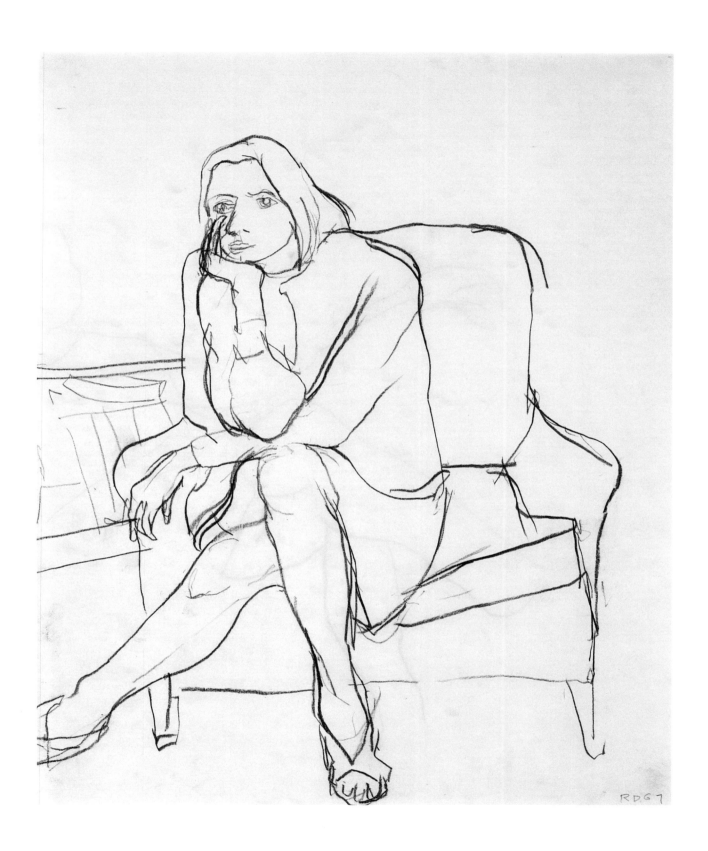

RDG7

PLATE 24

RD 752

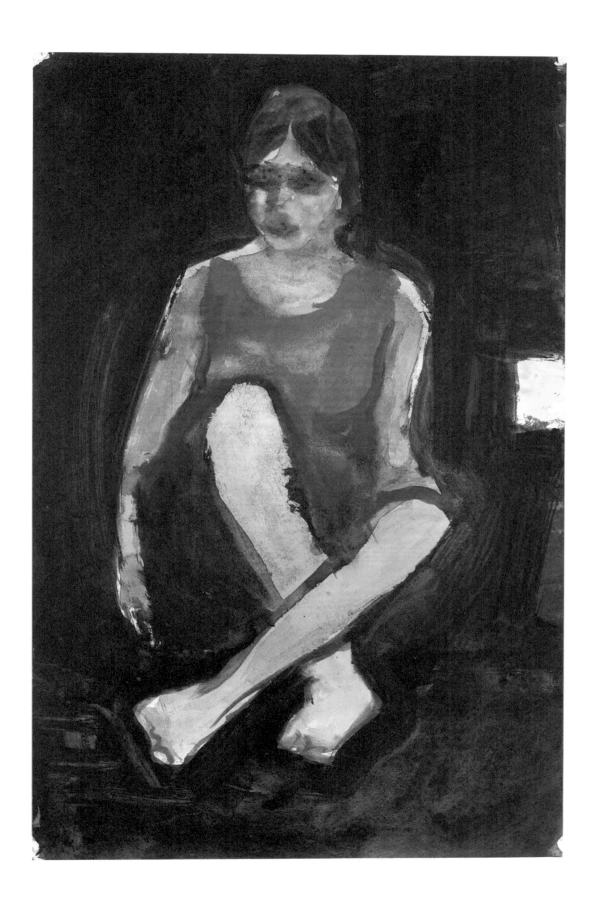

PLATE 25

RD 2087

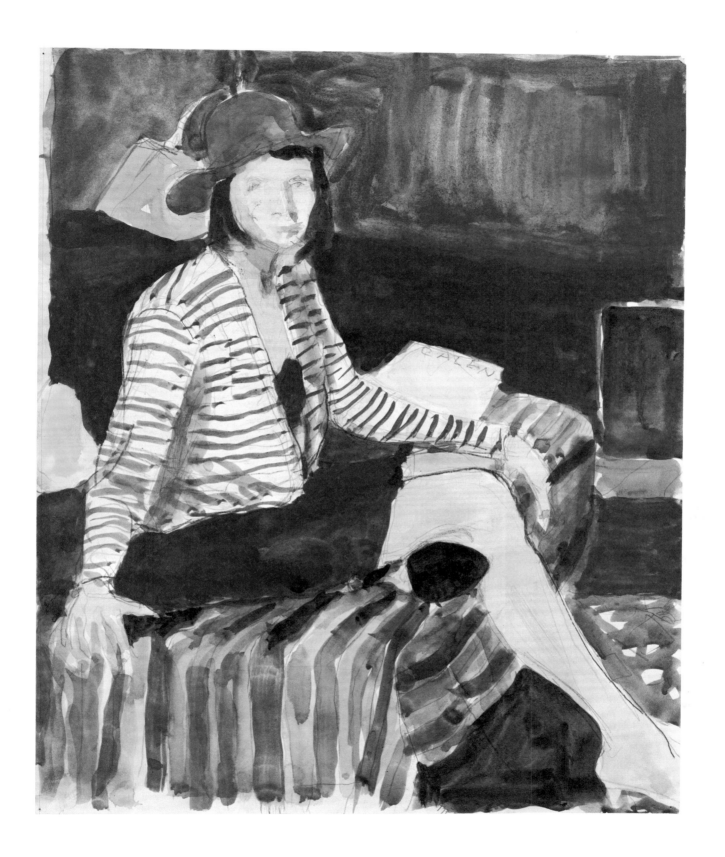

PLATE 26

RD 934

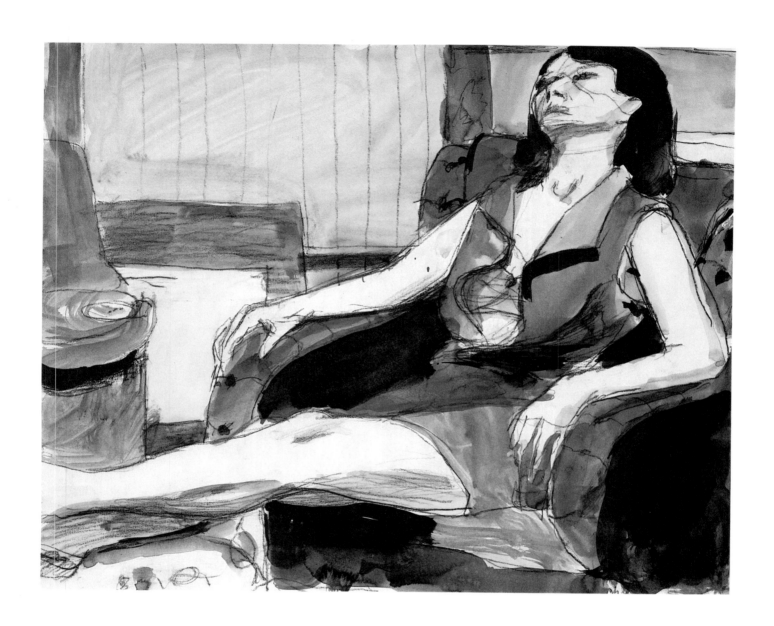

PLATE 27

RD 3587

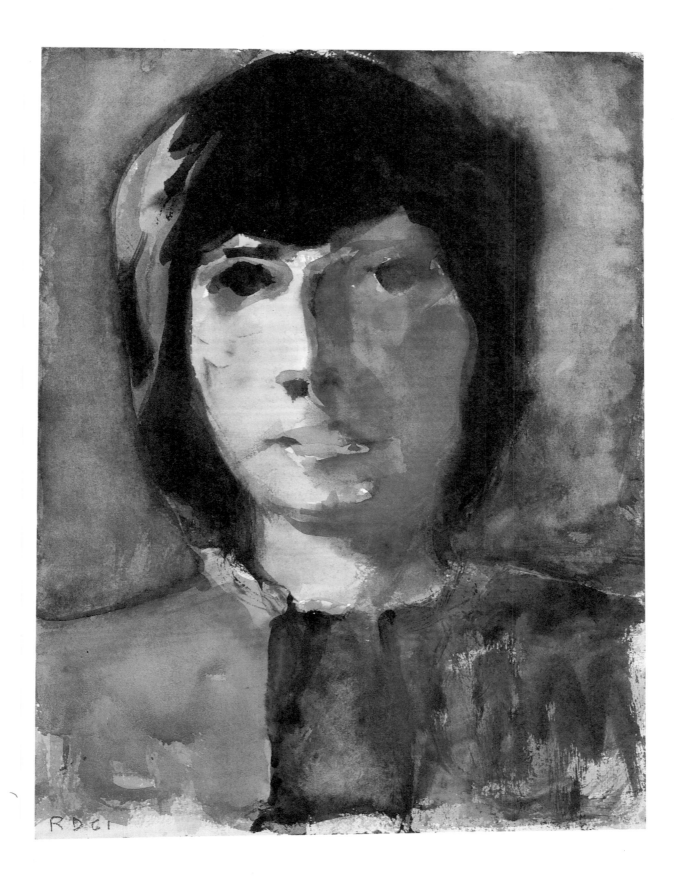

PLATE 28

RD 3588

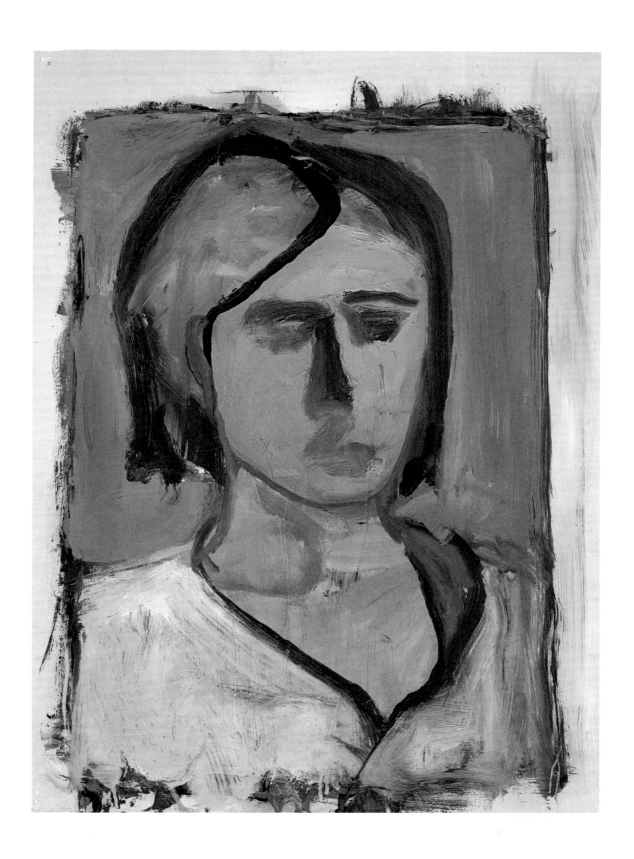

PLATE 29

RD 3597

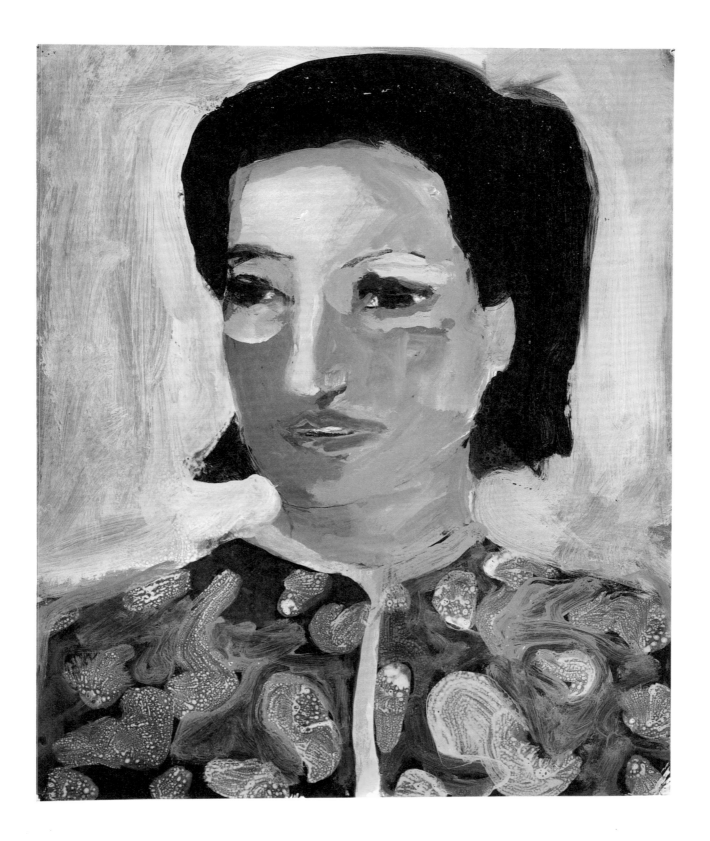

PLATE 30

RD 3598

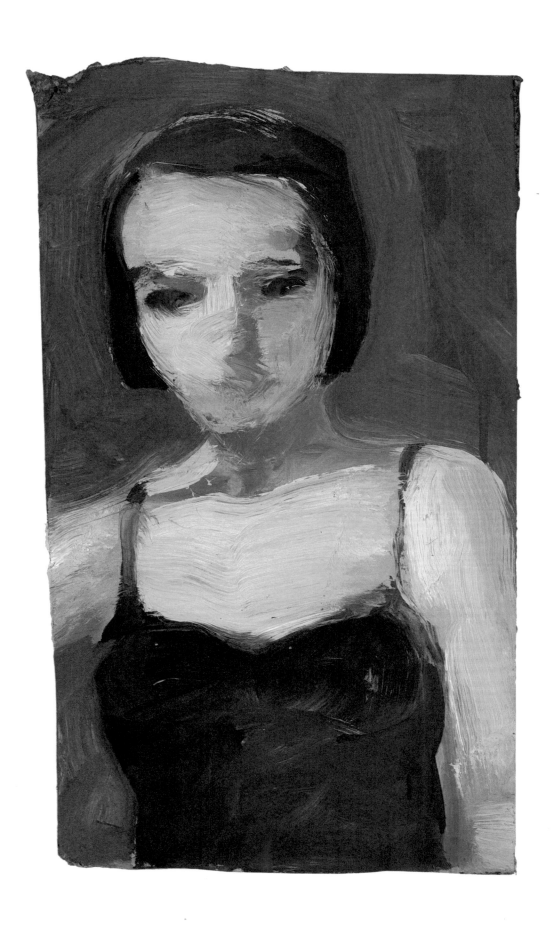

PLATE 31

RD 3602

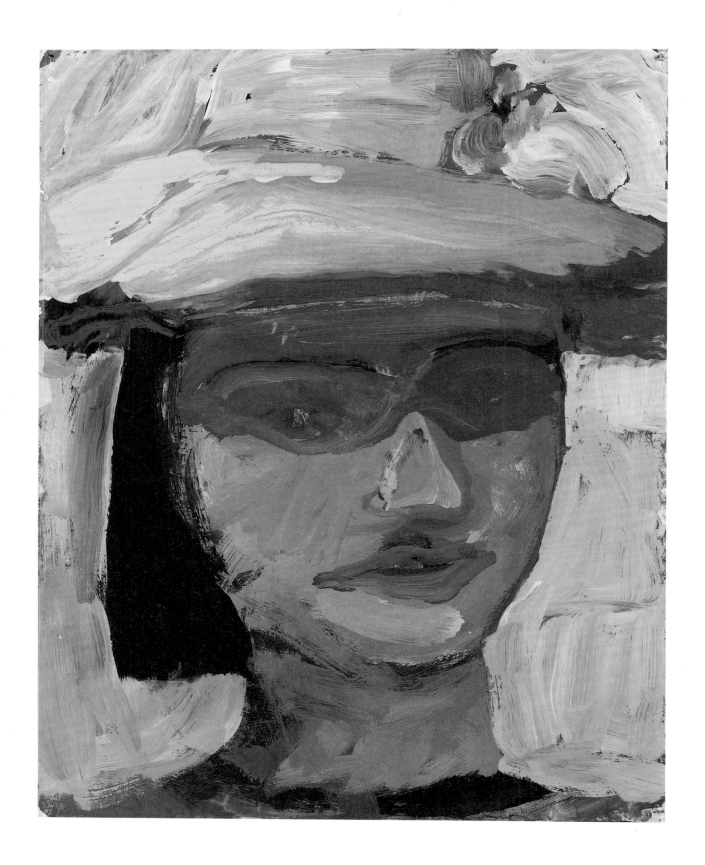

PLATE 32

RD 3604

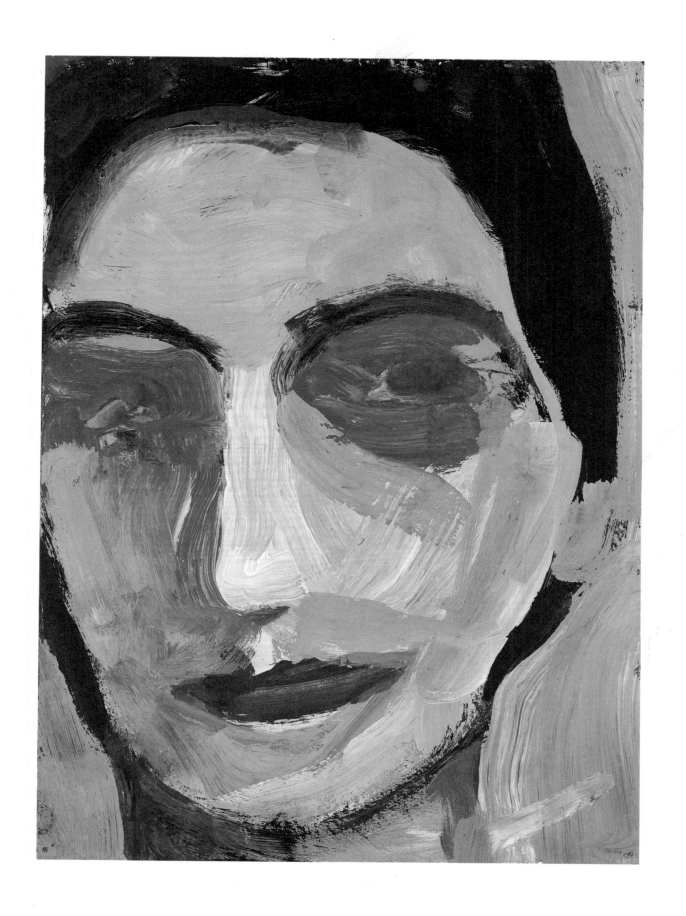

PLATE 33

RD 823

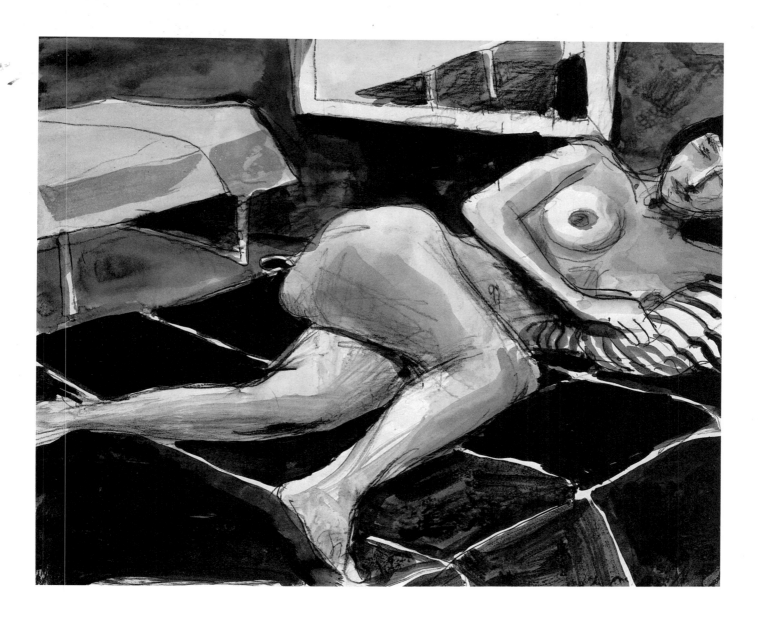

PLATE 34

RD 837

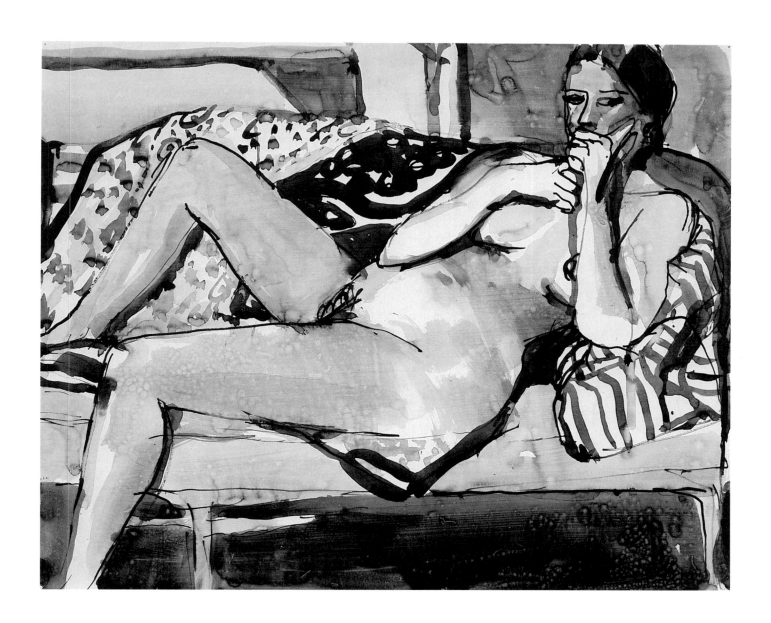

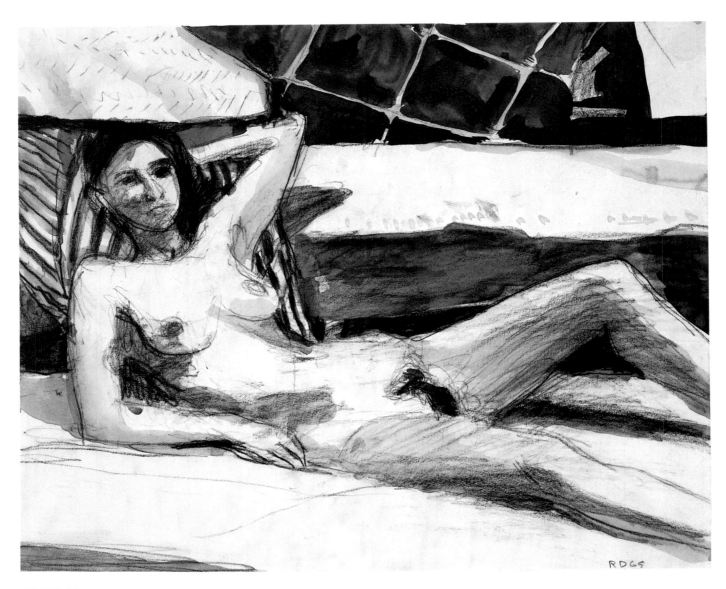

PLATE 35

RD 850

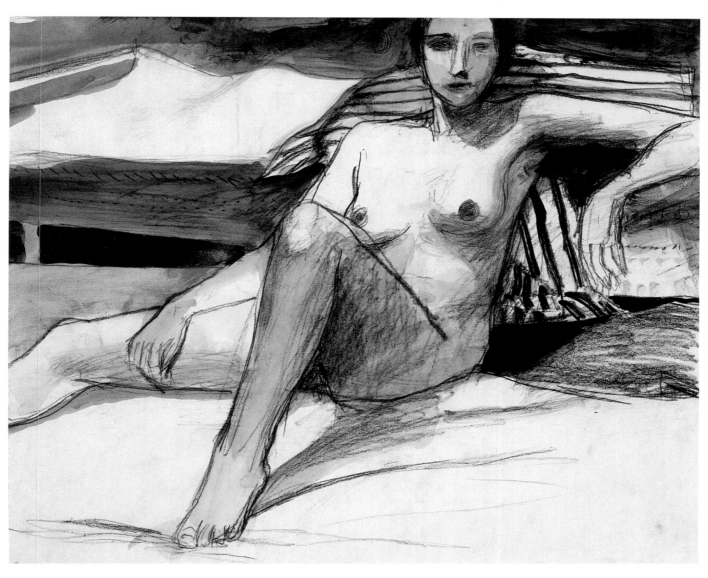

PLATE 36

RD 929

PLATE 37

RD 2021

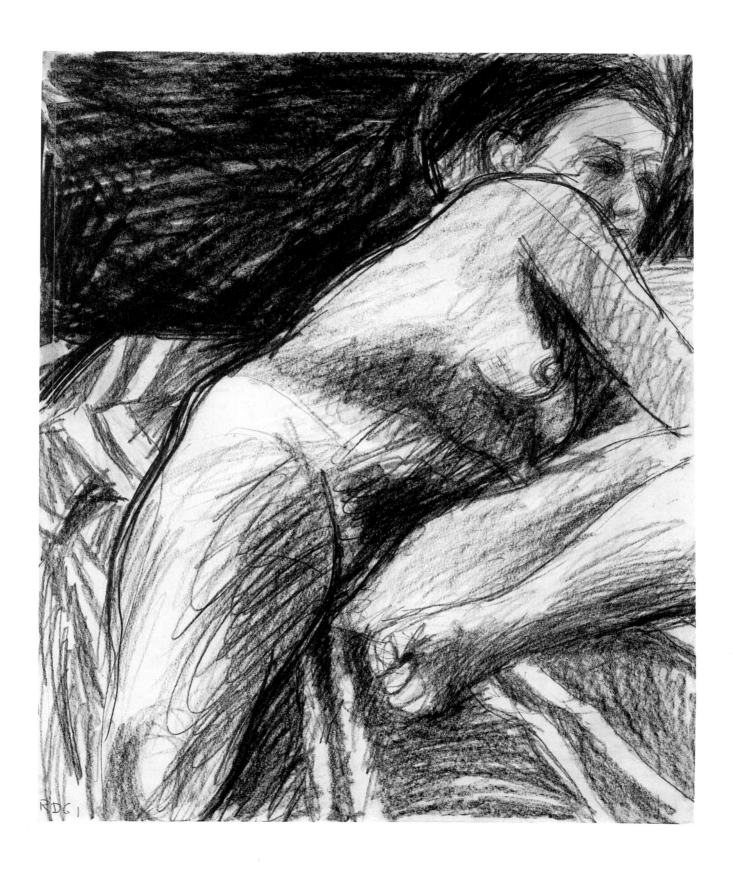

PLATE 38

RD 2192

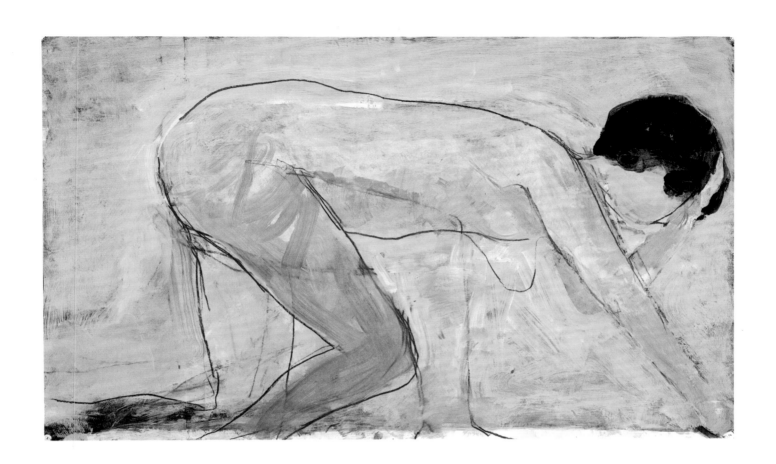

PLATE 39

RD 928

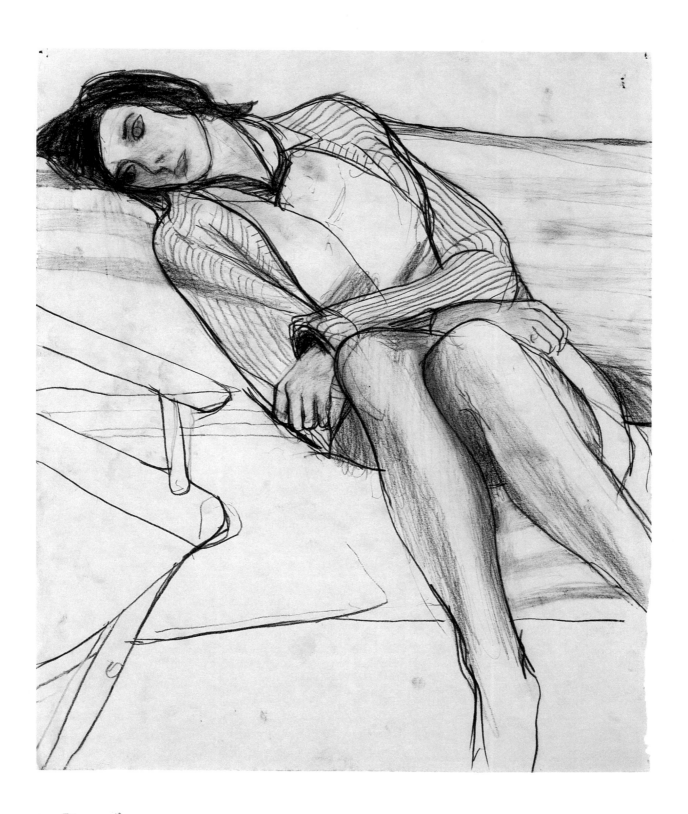

PLATE 40

RD 1672

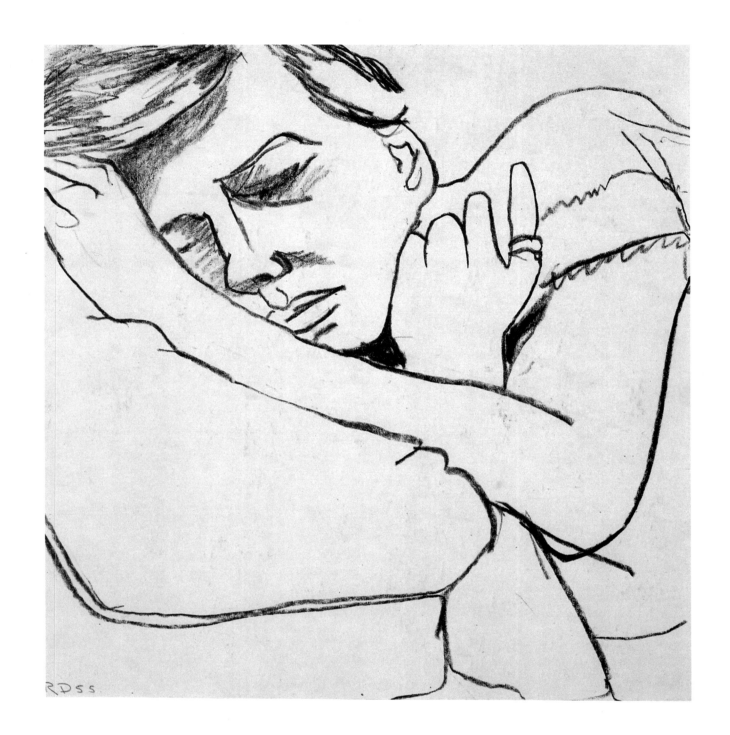

PLATE 41

RD 1693

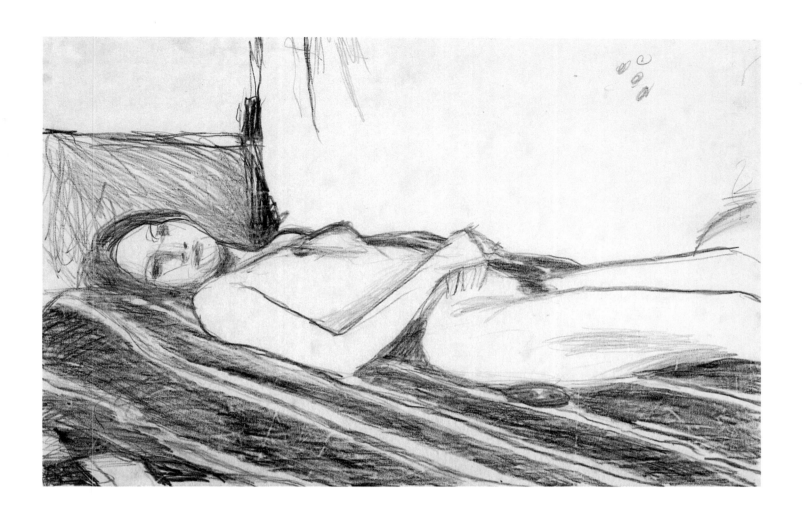

PLATE 42

RD 2057

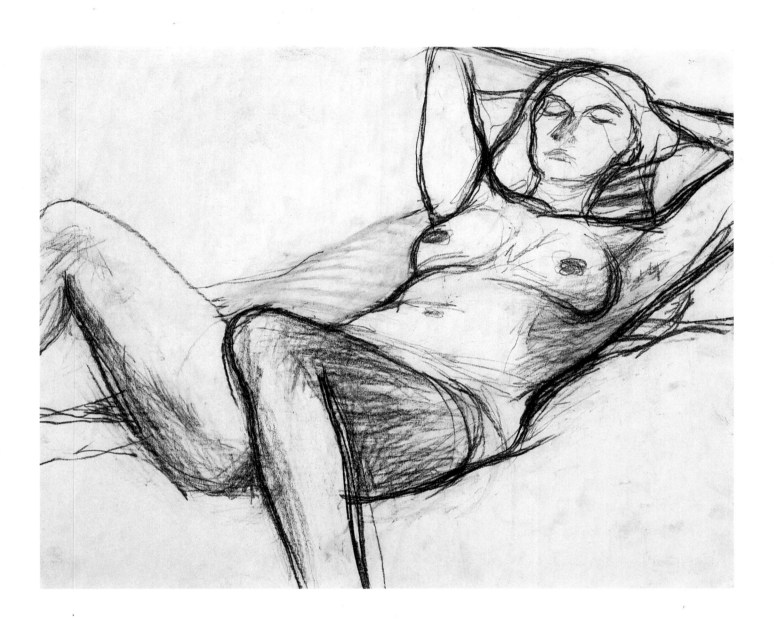

EXHIBITION CHECKLIST

1. Woman with Newspaper, 1960
 OIL ON CANVAS, 48 X 33¾ INCHES, RD 1302

2. Untitled, WATERCOLOR ON PAPER
 10¾ X 8½ INCHES, RD 743

3. Untitled, 1957-1958, GOUACHE AND
 WATERCOLOR ON PAPER, 16 X 10⅞ INCHES
 RD 751

4. Untitled, 1956, CHARCOAL ON PAPER
 16 X 11 INCHES, RD 810

5. Untitled, 1956-1966, CONTE CRAYON AND
 INK WASH ON PAPER, 16 X 11 INCHES, RD 511

6. Untitled (Standing Figure), 1956-1966
 CRAYON, GOUACHE AND GRAPHITE ON PAPER
 17 X 11 INCHES, RD 2096

7. Untitled, CHARCOAL AND INK WASH ON
 PAPER, 16⅞ X 13⅞ INCHES, RD 968

8. Untitled, INK ON PAPER, 17 X 14 INCHES
 RD 836

9. Untitled, PENCIL AND INK WASH ON PAPER
 17 X 14 INCHES, RD 878

10. Untitled, INK WASH AND CHARCOAL ON
 PAPER, 17 X 14 INCHES, RD 868

11. Untitled, INK WASH AND CHARCOAL ON
 PAPER, 17 X 14 INCHES, RD 889

12. Untitled, PENCIL AND INK WASH ON PAPER
 17 X 14 INCHES, RD 879

13. Untitled, 1956-1966, GOUACHE AND
 CHARCOAL ON PAPER, 17 X 14 INCHES
 RD 2101

14. Untitled, CHARCOAL ON PAPER
 17 X 14 INCHES, RD 831

15. Untitled, 1963, CHARCOAL ON PAPER
 16⅞ X 12⅜ INCHES, RD 925

16. Untitled, 1956-1966, GOUACHE ON PAPER
 17 X 12½ INCHES, RD 2088

17. Untitled, CHARCOAL AND INK WASH ON
 PAPER, 16⅞ X 13⅞ INCHES, RD 930

18. Untitled, 1967, CHARCOAL AND BALL POINT
 ON PAPER, 17 X 14 INCHES, RD 1735

19. Untitled, WATERCOLOR ON PAPER
 17 X 13⅜ INCHES, RD 782

20. Untitled, 1967, CHARCOAL, INK WASH AND
 BALL POINT ON PAPER, 14 X 17 INCHES
 RD 1734

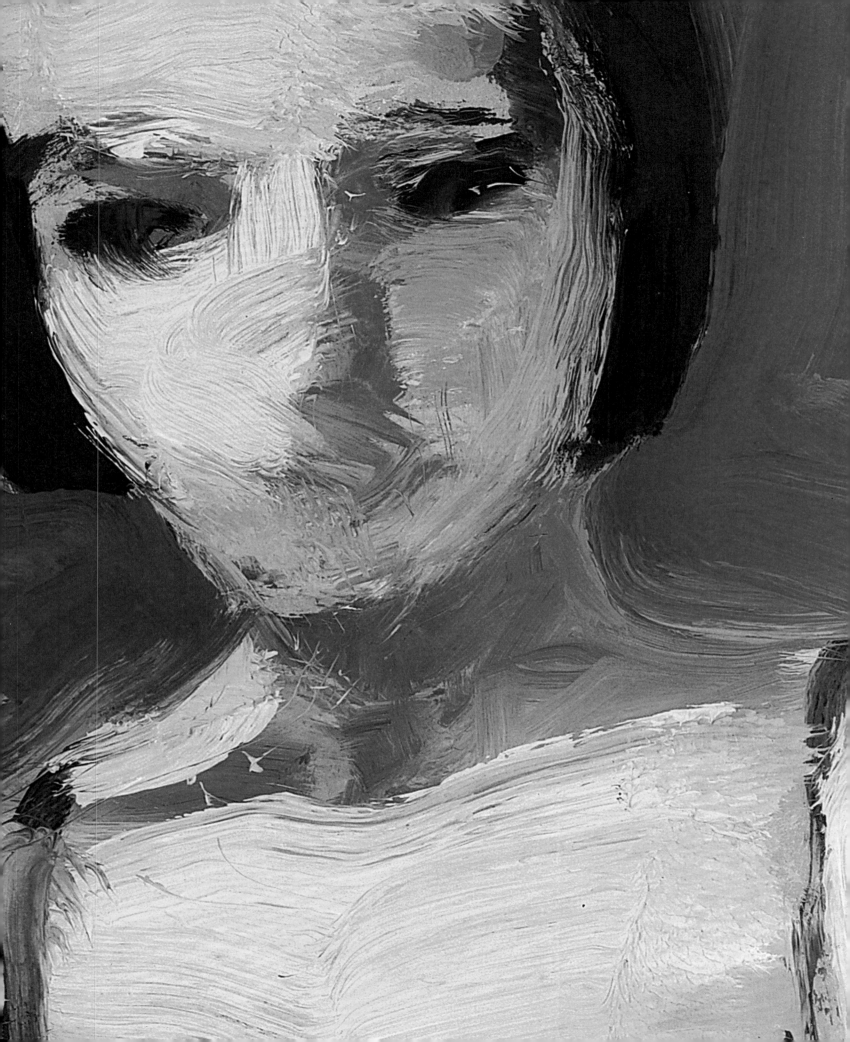

RICHARD DIEBENKORN IN HIS OCEAN PARK STUDIO

SANTA MONICA, CALIFORNIA, 1984

21. Untitled, 1956-1966, GOUACHE ON PAPER
 14 X 10 INCHES, RD 2098

22. Untitled, 1963, INK ON PAPER
 17 X 12½ INCHES, RD 975

23. Untitled, 1967, CHARCOAL ON PAPER
 17 X 14 INCHES, RD 2004

24. Untitled, GOUACHE AND WATERCOLOR ON
 PAPER, 17 X 11 INCHES, RD 752

25. Untitled, 1956-1966, GOUACHE AND PENCIL
 ON PAPER, 17 X 14 INCHES, RD 2087

26. Untitled, CHARCOAL AND INK WASH ON
 PAPER, 13⅞ X 16⅞ INCHES, RD 934

27. Untitled, 1961, GOUACHE AND WATERCOLOR
 ON PAPER, 11⅞ X 9 INCHES, RD 3587

28. Untitled, OIL ON PAPER, 19 X 15 INCHES
 RD 3588

29. Untitled, GOUACHE ON PAPER
 17 X 14 INCHES, RD 3597

30. Untitled, GOUACHE ON CARDBOARD
 16 X 9 INCHES, RD 3598

31. Untitled, GOUACHE ON PAPER
 11¼ X 14¼ INCHES, RD 3602

32. Untitled, GOUACHE ON PAPER
 11¼ X 8¼ INCHES, RD 3604

33. Untitled, CONTE CRAYON AND INK WASH
 ON PAPER, 14 X 17 INCHES, RD 823

34. Untitled, INK AND INK WASH ON PAPER
 14 X 17 INCHES, RD 837

35. Untitled, 1965, CHARCOAL AND INK WASH
 ON PAPER, 14 X 17 INCHES, RD 850

36. Untitled, CHARCOAL AND INK WASH ON
 PAPER, 13⅞ X 16⅞ INCHES, RD 929

37. Untitled, 1961, CHARCOAL ON PAPER
 17 X 14 INCHES, RD 2021

38. Untitled, 1956-1966, GOUACHE, OIL AND
 CRAYON ON PAPER, 19 X 31½ INCHES
 RD 2192

39. Untitled, CHARCOAL ON PAPER
 17⅝ X 14⅜ INCHES, RD 928

40. Untitled, 1955, CHARCOAL ON PAPER
 10⅜ X 10 INCHES, RD 1672

41. Untitled, CHARCOAL ON PAPER
 10⅞ X 17 INCHES, RD 1693

42. Untitled, CHARCOAL ON PAPER
 14 X 17 INCHES, RD 2057

RICHARD DIEBENKORN

Richard Diebenkorn was born in Portland, Oregon in 1922, and moved with his family to the San Francisco Bay Area in 1924. He attended Stanford University from 1940 to 1943, during which time he enrolled in the United States Marine Corps. The Marines sent him to continue his education at the University of California at Berkeley for a term in 1943, after which he served in the military until 1945. He attended the California School of Fine Arts the next year, then serving on its faculty from 1947 to 1949. He received his MFA from the University of New Mexico in 1951. Diebenkorn taught at the California College of Arts and Crafts from 1955 to 1959, then moved to the faculty of the San Francisco Art Institute, where he taught until 1963. That fall he accepted a yearlong residency at Stanford. In 1966, Diebenkorn moved to Southern California where he established his studio in the Ocean Park neighborhood of Santa Monica and taught at the University of California at Los Angeles. He returned to the Bay Area in 1986, settling in Healdsburg. He died in 1993. A major retrospective of his work, curated by Jane Livingston, was organized by the Whitney Museum of American Art in 1998.

SELECTED SOLO EXHIBITIONS

2003

"Figurative Works on Paper," John Berggruen Gallery, San Francisco, CA (catalogue)

2002

"Clubs and Spades," Fine Arts Museums of San Francisco, California Palace Legion of Honor, San Francisco, CA

"Figurative Drawings, Gouaches, and Oil Paintings," Artemis Greenberg Van Doren Gallery, New York, NY

2000

"Early Abstractions," Lawrence Rubin Greenberg Van Doren Fine Art, New York, NY

"Representational Drawings," Galleria Lawrence Rubin, Milan, Italy

1999

"Ocean Park Paintings," Lawrence Rubin Greenberg Van Doren Fine Art, New York, NY

"From Nature to Abstraction," Campbell-Thiebaud Gallery, San Francisco, CA

1997-98

"Richard Diebenkorn," The Whitney Museum of American Art, New York, NY. Traveled to Fort Worth Museum of Modern Art, Fort Worth, TX; The Phillips Collection, Washington, D.C.; San Francisco Museum of Modern of Modern Art, San Francisco, CA (catalogue)

"The Ocean Park Series: A Selection of Original Prints," John Berggruen Gallery, San Francisco, CA

1996

"Figure Drawings," Acquavella Contemporary Art, New York, NY (catalogue)

"Selected Works from 1949-1991," John Berggruen Gallery, San Francisco, CA

1995

"Abstractions," Galerie Lawrence Rubin, Zurich, Switzerland (catalogue)

"41 Etchings/ Drypoints, 1965, and Selected Rare Prints from 1961-62," John Berggruen Gallery, San Francisco, CA

"The Ocean Park Image, Paintings on Paper and Important Prints," John Berggruen Gallery, San Francisco, CA

"A Bay Area Connection: Works from the Anderson collection, 1954-1984," Triton Museum of Art, Santa Clara, CA (catalogue)

1994

"Blue Surround, Evolution of a Print," Fine Arts Museums of San Francisco, M. H. de Young Memorial Museum, San Francisco, CA, (catalogue)

"Ocean Park Paintings on Paper Never Before Exhibited," M. Knoedler & Co., New York, NY (catalogue)

"Small Format Oil on Canvas Figures, Still Lifes and Landscapes," M. Knoedler & Co., New York, NY (catalogue)

1993

"Works on Paper from the Harry W. and Mary Margaret Anderson Collection," Fisher Gallery,

University of Southern California, Los Angeles, CA
(catalogue)

1992
"Ocean Park Paintings," Gagosian Gallery, New York,
NY (catalogue)

1991
Whitechapel Art Gallery, London, Traveled to the
Fundacion Juan March, Madrid, Spain; Frankfurter
Kunstverein, Frankfurt, Germany; The Museum of
Contemporary Art, Los Angeles, CA; San Francisco
Museum of Modern Art, San Francisco, CA
(catalogue)

1989
"Graphics 1981-1988," Yellowstone Art Center,
Billings, MT. Traveled to the Modern Art Museum of
Fort Worth, Fort Worth, TX; Tacoma Art Museum,
Tacoma, WA; The Arkansas Arts Center, Little Rock,
AR (catalogue)

1988
"The Drawings," The Museum of Modern Art,
New York, NY. Traveled to the Los Angeles County
Museum of Art, Los Angeles, CA; San Francisco
Museum of Modern Art, San Francisco, CA; The
Phillips Collection, Washington, D.C. (catalogue).
"Monotypes," Pamela Auchincloss Gallery, New York,
NY (catalogue)

1987
"Recent Work," M. Knoedler & Co., New York, NY
(catalogue)

1986
"1981-1986," Crown Point Press, New York, NY

1985
"Recent Work," M. Knoedler & Co., New York, NY
(catalogue)
"Small Paintings from Ocean Park," Sheldon
Memorial Art Gallery, University of Nebraska,
Lincoln, NE. Traveled to the Brooklyn Museum,
Brooklyn, NY (catalogue)

1984
"A Portfolio of 41 Etchings and Drypoints Published
in 1965," L. A. Louver Gallery, Venice, CA
"Recent Work," M. Knoedler & Co., New York, NY
(catalogue)

1983
"Paintings 1948-1983," San Francisco Museum of
Modern Art, San Francisco, CA (catalogue)
"Works on Paper," John Berggruen Gallery, San
Francisco, CA

1982
"Etchings," Crown Point Gallery, Oakland, CA
(catalogue)
"Intaglio 1961-1980," The Brooklyn Museum,
Brooklyn, NY
M. Knoedler & Co., New York, NY (catalogue)

1981
"Etchings and Drypoints, 1949-1980," The
Minneapolis Institute of Arts, Minneapolis, MN.
Traveled to The Nelson-Atkins Museum of Art,
Kansas City, MO; The Saint Louis Art Museum, Saint

Louis, MO; The Baltimore Museum of Art, Baltimore, MD; Carnegie Institute, Pittsburgh, PA; The Brooklyn Museum, Brooklyn, NY; Flint Institute of Arts, Flint, MI; Springfield Art Museum, Springfield, MO; University of Iowa Museum of Art, Iowa City, IA; Sarah Campbell Blaffer Gallery, University of Houston, Houston, TX; Newport Harbor Art Museum, Newport Beach, CA; San Francisco Museum of Art, San Francisco, CA (catalogue)
"Matrix/ Berkeley 40," University Art Museum University of California, Berkeley, CA (catalogue)

1980
M. Knoedler & Co., New York, NY (catalogue)

1979
M. Knoedler & Co., New York, NY (catalogue)

1978
"From Nature to Art, from Art to Nature," American Pavilion, XXXVIIIth Venice Biennale, Venice, Italy (catalogue)
M. Knoedler & Co., New York, NY (catalogue)

1977
M. Knoedler & Co., New York, NY (catalogue)
"Paintings and Drawings, 1943-1976," The Corcoran Gallery of Art, Washington, D.C. (catalogue)

1976
"Monotypes," Frederick S. Wright Gallery, University of California, Los Angeles, CA (catalogue)
"Paintings and Drawings 1943-1976," Albright-Knox Art Gallery, Buffalo, NY. Traveled to the Cincinnati Art Museum, Cincinnati, OH; The Corcoran Gallery of Art, Washington, D.C.; Whitney Museum of

American Art, New York, NY; Los Angeles County Museum of Art, Los Angeles, CA; The Oakland Museum, Oakland, CA (catalogue)

1975
"Early Abstract Works, 1948-1955," James Corcoran Gallery, Los Angeles, CA. Traveled to the John Berggruen Gallery, San Francisco, CA (catalogue)
"The Ocean Park Series; Recent Work," Marlborough Gallery, New York, NY

1974
"Drawings, 1944-1975," Mary Porter Sesnon Gallery, University of California, Santa Cruz, CA (catalogue)

1973
Robert Mondavi Gallery, Oakville, CA
"The Ocean Park Series: Recent Work," Marlborough Fine Art, London, England and Marlborough Galerie, Zurich, Switzerland (catalogue)

1972
"Lithographs," Gerard John Hayes Gallery, Los Angeles, CA (catalogue)
"Paintings from the Ocean Park Series," San Francisco Museum of Art, San Francisco, CA (catalogue)

1971
Irving Blum Gallery, Los Angeles, CA
"Ocean Park Series: Recent Work," Marlborough Gallery, New York, NY (catalogue)
Poindexter Gallery, New York, NY
Smith Anderson Gallery, Palo Alto, CA

1969
"Drawings," Poindexter Gallery, New York, NY (catalogue)
"New Paintings," Los Angeles County Museum of Art, Los Angeles, CA (catalogue)

1968
"Drawings," Pennsylvania Academy of the Fine Arts, Philadelphia, PA
Nelson Gallery-Atkins Museum, Kansas City, MO
Poindexter Gallery, New York, NY
Richmond Art Center, Richmond, VA (catalogue)

1964
"Drawings," Stanford University Art Gallery, Palo Alto, CA (catalogue)
Washington Gallery of Modern Art, Washington, D.C. Traveled to The Jewish Museum, New York, NY; Pavilion Gallery, Newport Beach, CA (catalogue)

1963
"Paintings 1961-1963," M.H. de Young Memorial Museum, San Francisco, CA
Poindexter Gallery, New York, NY

1962
National Institute of Arts and Letters, New York, NY

1961
The Phillips Collection, Washington, D.C. (catalogue)
Poindexter Gallery, New York, NY

1960
Pasadena Art Museum, Pasadena, CA (catalogue)
"Recent Paintings," California Palace of the Legion of Honor, San Francisco, CA (catalogue)

1957
Swetzoff Gallery, Boston, MA

1956
Oakland Art Museum, Oakland, CA
Poindexter Gallery, New York, NY

1954
Allan Frumkin Gallery, Chicago, IL
Paul Kantor Gallery, Los Angeles, CA
San Francisco Museum of Art, San Francisco, CA

1952
Paul Kantor Gallery, Los Angeles, CA
Oakland Art Museum, Oakland, CA

1951
"Master's Degree Exhibition," University Art Museum of New Mexico, Albuquerque, NM

1948
California Palace of the Legion of the Honor, San Francisco, CA

Figurative Works on Paper. Exhibition catalogue. Introduction by John McEnroe, essays by Jane Livingston and Barnaby Conrad III. San Francisco, CA: John Berggruen Gallery, 2003.

Richard Diebenkorn: Figurative Drawings, Gouaches, and Oil Paintings. Exhibition catalogue. New York, NY: Artemis Greenberg Van Doren Gallery, 2002.

Richard Diebenkorn: Early Abstractions. Exhibition catalogue. New York, NY: Lawrence Rubin Greenberg Van Doren Fine Art, 2000.

Richard Diebenkorn: Representational Drawings. Exhibition catalogue. Milan, Italy: Galleria Lawrence Rubin, 2000.

Richard Diebenkorn: Ocean Park Paintings. Exhibition catalogue. New York, NY: Lawrence Rubin Greenberg Van Doren Fine Art, 1999.

Richard Diebenkorn: From Nature to Abstraction. Exhibition catalogue. Essay by Stephen Nash. San Francisco, CA: Campbell-Thiebaud Gallery, 1999.

Livingston, Jane. *The Art of Richard Diebenkorn.* Texts by John Elderfield, Ruth E. Fine, and Jane Livingston. New York, NY: The Whitney Museum of American Art, 1997.

Richard Diebenkorn Abstraktioner. Exhibition catalogue. Zurich, Switzerland: Galerie Lawrence Rubin, 1995.

Richard Diebenkorn. Introduction by Catherine Lampert, text by John Elderfield. London, England: Whitechapel Art Gallery, 1991.

Elderfield, John. *The Drawings of Richard Diebenkorn.* New York, NY: The Museum of Modern Art, 1988.

Nordland, Gerald. *Richard Diebenkorn.* New York, NY: Rizzoli International Publications, 1987; Revised 2001.

Newlin, Richard. *Richard Diebenkorn: Works on Paper.* Houston, Texas: Houston Fine Art Press, 1987.

Richard Diebenkorn: Etchings and Drypoints, 1949-1980. Exhibition catalogue. Introduction by George W. Neubert, text by Dore Ashton. Lincoln, NE: Sheldon Memorial Art Gallery, University of Nebraska, 1985.

Richard Diebenkorn: Paintings and Drawings, 1943-1980. Texts by Robert Buck, Jr., Linda L. Cathcart, Gerald Nordland, and Maurice Tuchman. Exhibition catalogue. Buffalo, NY: Albright-Knox Art Gallery, 1976; revised edition, 1980.

Drawings by Richard Diebenkorn. Exhibition catalogue. Introduction by Lorenz Eitner. Palo Alto, CA: Stanford University Art Gallery, 1965.

41 Etchings, Drypoints. Berkeley, CA: Crown Point Press, 1965.

This catalogue is copublished by John Berggruen Gallery and Chronicle Books LLC to accompany the exhibition

RICHARD DIEBENKORN
FIGURATIVE WORKS ON PAPER

March 19 through April 26, 2003
John Berggruen Gallery, San Francisco

Library of Congress Cataloging-in-Publication Data available
ISBN 0-8118-4218-5 [hc]
ISBN 0-8118-4219-3 [pb]

Design: Dan Miller Design, New York, NY
Printing: Finlay Printing, Bloomfield, CT

Project coordination: Kira Morris
Plate photographs by M. Lee Fatherree
Portrait and studio photographs of Richard Diebenkorn by Leo Holub

Distributed in Canada by Raincoast Books
9050 Shaughnessy Street
Vancouver, British Columbia V6P 6E5

10 9 8 7 6 5 4 3 2 1

Chronicle Books LLC
85 Second Street
San Francisco, California 94105
www.chroniclebooks.com

John Berggruen Gallery
228 Grant Avenue
San Francisco, CA 94108
www.berggruen.com

This publication and the exhibition it documents would not have been realized without the help of many people. We would like to express our warmest gratitude to the Diebenkorn, family: Phyllis Diebenkorn, Gretchen Diebenkorn Grant and Richard Grant, as well as to Christopher Diebenkorn. We would like to offer special thanks to Jane Livingston, Barnaby Conrad III and John McEnroe for their informative essays and to our friend and colleague, Lawrence Rubin, for making this exhibition possible. We are indebted to Dan Miller for his inspired design of this book and to Nion McEvoy and Alan Rapp of Chronicle Books for their support of this project. We extend our thanks as well to our steadfast staff. Kira Morris has been invaluable as coordinator of the exhibition catalogue. We thank as well Sheila Halley, Meredith Calhoun, Nicholas Olney and Suzanne Sennett.

COVER: *Untitled*, 1957-1958, Gouache and watercolor, 16 x 10in. (40.6 x 27.6 cm), RD 751, Plate 2

PAGE 10: Detail: *Untitled*, 1956-1966, Gouache and pencil on paper, 17 x 14 inches, RD 2087, Reproduced in its entirety Plate 25

PAGE 16-17: Richard Diebenkorn in his studio Stanford, California, 1963

PAGE 94: Detail: *Untitled*, Gouache on corrugated cardboard Overall: 16 x 9 inches, RD 3598, Reproduced in its entirety Plate 30